10¢

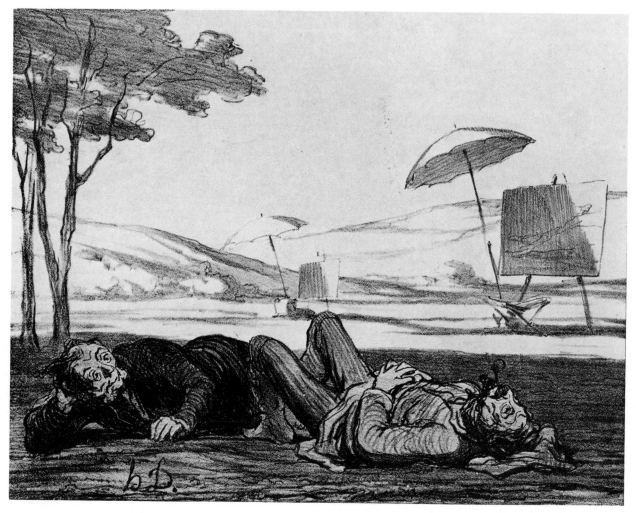

"Landscape Painters at Work," lithograph by Honoré Daumier.

The Pleasures of
SKETCHING
OUTDOORS

by

CLAYTON HOAGLAND

Second Edition

Dover Publications, Inc.
New York

Published in Canada by General Publishing Company, Ltd., 30 Lesmill Road, Don Mills, Toronto, Ontario.
Published in the United Kingdom by Constable and Company, Ltd., 10 Orange Street, London WC 2.

This Dover edition, first published in 1969, is an unabridged republication, with minor revision, of the work originally published by The Viking Press in 1947.
A supplement of 19 master drawings has been added to this reprint edition.

Standard Book Number: 486-22229-2
Library of Congress Catalog Card Number: 70-95244

Manufactured in the United States of America
Dover Publications, Inc.
180 Varick Street
New York, N.Y. 10014

To the memory of my Father
who first taught me the art in drawing.

ACKNOWLEDGMENTS

The author acknowledges with gratitude the courtesy of museums, galleries, artists and photographers from whom drawings and photographs were borrowed, and thanks in particular The Metropolitan Museum of Art, the Whitney Museum of American Art, the Frick Art Reference Library, the Carroll Carstairs Gallery and the Milch Gallery, all of New York, and The Cleveland, Ohio, Museum of Art; E. P. Dutton & Co., Inc., New York, for permission to quote from "An Essay on Landscape Painting" by Kuo Hsi. Artists who gave permission for use of their work were: Letterio Calapai, Violetta Glemser, Michel G. Gilbert, Frank Herbst, Seymour Snyder, John Whorf and Yeh Chien-yu. Norris Harkness, Harriet Wiesner and Patricia McNierney loaned photographs; Helen Carlson of the New York *Sun* read the finished manuscript and offered important suggestions; Kathleen Hoagland, the author's wife, not only typed the final draft of the text but gave valuable advice on improving both text and illustrations.

CONTENTS, INCLUDING ILLUSTRATIONS

(The illustration references are indicated by italics)

ABOUT THIS BOOK

SO YOU have an urge to sketch out of doors? Nothing could be more natural. The noted British scientist Julian Huxley has reported that while visiting the zoo in Regent's Park, London, he and a friend watched Meng, a young mountain gorilla that was kept in a lighted cage, trace with its forefinger the outline of its shadow on the wall. Huxley therefore expressed the belief that human graphic art may have had an origin, among our primitive ancestors, in a similar tracing of shadows cast by a low sun against a vertical cave wall.

The urge to draw seems as normal in young children as the urge to dance and sing, yet many youngsters forget, as they grow, the pleasure to be found in drawing. The urge may remain suppressed for years until an opportunity occurs to satisfy it. Amateurs in sketching are usually those men and women who, whatever their age, have kept on drawing since childhood or have taken it up for the enjoyment alone. The author of this book has intended to encourage in practical ways all who wish to begin sketching out of doors.

This book is designed to serve as a friendly, informal guide. Many manuals of instruction on sketching have been written by professional landscape painters who know their art well, but few of them have had a clear understanding of the needs and purposes of amateurs who sketch for the fun of it. You will find that the pages of this book are not cluttered with the technical jargon of professionals. It tells of simple and inexpensive ways to create genuine landscape drawings done from nature. Though it considers carefully both perspective and pictorial composition, it does not deal exhaustively with either subject.

The whole purpose has been to offer a series of lucid lessons in the fundamental art of sketching, and thereby to induce readers to develop in the practice of a delightful hobby. They should be able to improve their own style of working, so long as they proceed on the basis of a few sound principles observed through the ages by men who have mastered the art. Even the best of those masters had to begin by making his first outdoor sketch.

The Pleasures of
SKETCHING
OUTDOORS

I. THE HOBBY AND THE ART

THE MAN WHO WENT OUT

ONE of my best friends is a city schoolteacher. For years he talked to classes of adolescents about plural verbs and the beauties of Poe, Kipling, and Edna St. Vincent Millay. He rarely left his furnished room except at night, and then only to eat. Most of his week-ends were spent correcting papers, and he sat over books until the small hours. This was bad for his figure. Through the years he became round-shouldered and developed a paunch. He suffered from fatty tissue of the mind, for his life was too full of work. Then he found a wonderful way of escape that has given him more real pleasure than anything else he has ever done.

Drawing seemed hard going at first.

Around the corner from the teacher lived a young artist, Carlos, who earned his bread by painting portraits and murals. He found release from nervous tension by making outdoor sketches in spare daylight hours. He induced the teacher to go along on a week-end trip to a mountain resort. There the teacher's hand itched for pencil and paper. He tried drawing landscapes. No miracles happened, but he found a hobby that probably saved his life. It reduced his waistline and quickened his spirit.

Drawing seemed tough going at first, for he had done little of it as a child. He

3

kept at it. Under the eye of Carlos, and after several week-ends of practice, he learned what makes a sketch. Later came experiments in water colors and oil paints. Some of the pictures by this amateur are remarkable. He has sketched on vacation trips abroad, and many of the drawings and paintings he brought back have gone into exhibitions. His main purpose is twofold: to satisfy a long-smothered urge to be creative, and to escape from the drudgery of his daily work.

One of his dividends has come in a deeper understanding of the world's best art. In galleries and museums he no longer stares in stupid awe. He finds in pictures by old masters and modern artists alike a pleasure that can be had only through the actual experience of sketching. He has known the joy of making an art one of the most fascinating of hobbies. And he didn't discover this source of fun until he was forty!

Outdoor sketching is more than fun, of course. Just as an album full of vacation snapshots can bring back memories of past pleasures, so a portfolio of drawings of seacoast or rural scenery makes a personal artistic record of a place or a journey. Whether you travel by boat or train or motorcar, or hike across country, you pass through miles of scenic beauty which can be caught piecemeal, as it were, upon the pages of a sketching pad. Older parts of your town or city are changing rapidly as landmarks are destroyed, historic houses demolished, to make way for new buildings. Such places should not be wholly forgotten, and even an amateur's drawing or painting may preserve the essential appearance of a landmark and have value apart from any artistic merit it may possess.

THE PLUMBER OF BERGHOLT

Let us admit that most artistic talent seems to be inborn. But it crops out in odd places. When the great British painter John Constable was a boy, he found only one person in the village of Bergholt who was interested in art, and that was a plumber and glazier who spent his leisure hours painting landscapes from nature. This man encouraged young Constable, and because Constable later became a powerful influence on the French Impressionists, the plumber of Bergholt earned a place in the history of art. But he probably cared only for the fun he had.

4

The original of this pencil drawing by John Constable is about 12 x 8 inches.

Nobody should expect to learn easily how to sketch well out of doors. If landscape drawing were simple, it would offer no challenge to an amateur's spirit of adventure. Constable once wrote to a friend: "If you had found painting as easy as you once thought it, you would have given up long ago." Any good golfer who ever swung a niblick begins every game in the belief that he is about to break his own record. The sketcher has one big advantage—he has no record that can be figured in scores. Only his self-satisfaction with the result counts, and that is boundless. So he keeps trying, enjoys the pastime, and improves his art.

WHAT DOES THE AUTHOR SAY?

Twenty-six years ago, when I was still in my teens, I began sketching outdoors, without professional guidance. From that time I have never ceased to sketch when spare hours have made the opportunity, except in winter months, when the rewards of summer field trips have been used in ways I shall later reveal. I can recall my chief problems

5

at every stage of development. Some of the products of this quarter-century of land-scape drawing and painting have been displayed in museums and art club exhibitions. Some have gone to friends and relatives as Christmas gifts. Many sketches adorn the walls of my own house. But all these are only minor sources of pleasure as compared with the fun of sketching itself. No, joy is more intense than that which the amateur gets from the actual performance. The admiration of others for the finished work is always pleasant, but you soon learn to believe only half of what your friends say when they are complimentary.

The real delight comes in wrestling with some tough problem in pictorial com-position and mastering it. The problems have been met face to face everywhere: In my back yard, in open fields at the edge of my suburban home town, in city parks and streets. The problems have been seen and overcome from hotel windows, from the deck of an Ohio River steamboat, from Cape Cod beaches, from Connecticut farmyards, from the shores of islands off the Atlantic coast, from hills and harbors of Eire and Scotland. Yet no pleasure from sketching has surpassed that which I find anew, every spring, in jaunts within a mile of my house. Some of the most unusual adventures I have ever had came as by-products of casual sketching trips made after breakfast on days off from my newspaper work. It is a hobby that leads to queer and uncommon human contacts.

THE OUTDOORS INSIDE

The landscape sketcher gets limitless joy from tours and motor trips, yet he never needs to travel far to exercise his hobby. The city dweller or the suburban commuter can begin at any season right where he is. In a few months, or even weeks, he can train his hand and eye. Some of the best amateur artists I know rarely leave the city.

The world is outside your own door. The shape of it, in a vast variety of forms, can be seen from your windows and can be spread upon a sheet of paper on your table. In fact, in our homes are rich mines of material for practice on those cold or wet week-ends or evenings when no opportunity is at hand for two hours in the park, or at the beach, or on the river bank.

6

Problems in composition are found in suburban backyards and in city streets, and solved in rough sketches.

We shall return to the world outside after we have made practical use of the pictorial material on hand at home. The world inside is in small bits and pieces, yet they are precious fragments of the great masterpiece which is nature. This may sound highfalutin, but it will be proved.

Whether you prefer modern painters, or the older, conservative styles in art, the basic process of sketching will be the same. The final product may be as formal as a Currier & Ives print, or as free and explosive in style as a child's drawing. That's up to *you,* and it will depend on your background, your taste, and your natural inclinations. But whatever your purpose, you must first master the art of *looking* at landscape, and train yourself to see it as an artist should. That is essential.

OH, HOW CAN YOU SEE?

There is not much sense in trying to draw natural landscape until you have learned what to see, and *how* to see it. You must, by practice, come to know how to look at the shape of the land, and at the queer handiwork of man that is upon it, in the form of houses, skyscrapers, and chicken coops.

Don't ever believe that talent is all in the way an artist uses his brush or crayon to get effects of light, color, or line. The artist's ability lies first in *seeing* the picture before he has begun it. In the next few pages you should find all the clues you will need to the art of seeing landscape in the way that you wish to draw it. Between a bungling, untrained beginner and a Constable, a Winslow Homer, or a Cézanne, is a vast world of difference, but a great deal of that difference is in how the experienced artist looks at the world. Remember, no hand holding a pencil can be more skillful in drawing than the eye which guides it.

A Chinese painter, Kuo Hsi, once put down a few truths about his art, saying that if an artist "is confused and has cloudy ideas, then the forms become obscure and uncertain." It was his firm belief that good landscape sketching requires that the artist put his whole soul into his work. This is the Oriental way of saying that clearness of vision is important. When you have learned to look at streets and mountains, fields and beaches, lakes and rivers, without bewilderment, the practical matter of drawing will have been reduced fifty per cent. Now let us test this theory.

8

YOUR EYE AND THE CAMERA

Look through a window in full daylight (but not against the sun) for one or two minutes, and consider the confusing pattern outside—and if it be only a brick wall, try another window. It should be a pattern of colors, shapes, masses, and lines: the foliage of trees in the yard, a square of green lawn, the flat plane of the street, a parked automobile, the blonde next door walking her black terrier, the shadows and streaks of sunlight on the sidewalk, the vertical bulk of a building or house across the street, and white clouds floating in the sky.

No artist in his right mind would attempt to paint all that! A trained eye selects the three or four interesting elements with which to make a strong sketch.

Courtesy of the Whitney Museum of American Art.
"Overlooking Valhalla," a drawing in lithograph crayon by Thomas Donnelly (1920).

Now open an album of vacation snapshots or a magazine with travel pictures, or study some postcards with landscape subjects. In such pictures there is an *order* which is in sharp contrast to the disorder of a view from your window. Artistry produced the order. A magazine photograph, for example, has probably been trimmed down from a larger negative. The camera lens reflected the same apparent confusion that met your eye when you looked through the window; but the camera reduced it to black and white and was *focused* to bring out certain features strongly. The reduction of any natural scene in colors to the black, white, and gray of a print is one big step out of confusion toward order. The expert photographer chooses an interesting subject. Then he may trim down his print to leave a strong composition, cutting away a tree, or the cornice of a building. That is a further step toward order. A retoucher who worked on the print for the magazine may have darkened one area with a wash of gray paint, and brightened another. This sharpened the emphasis which the camera got by proper *focus*.

AND NOW TO WORK

With a thick, soft lead pencil copy *roughly* a simple snapshot or postcard of scenery —sand dunes, a lake with foreground trees, or a range of hills. Let us forget the human figures that may be in it. Omit also such objects as boats, vehicles, and the small branches of trees. Don't be too precise about the contour of hills, and leave the windows out of any buildings in the picture. The purpose of this rough copy is to *simplify* a photograph in terms of black and gray areas.

You cannot learn to draw landscapes by copying photographs. At this stage you are learning to *see* the design—the basic shape, in dark and light tones—in a scene that would appear confusing if you were on the spot where the picture was taken. The original photographer may have composed well or badly, but at least there was some *selection,* and maybe some trimming, to simplify the whole composition. You will probably be satisfied with your rough pencil copy only after you have made two or three, and discarded one photograph for another. Your "rough" need not be much larger than a postcard, but is more easily drawn when 5 x 7 or larger.

The practiced landscape sketcher learns to do by eye all the selecting and "focus-

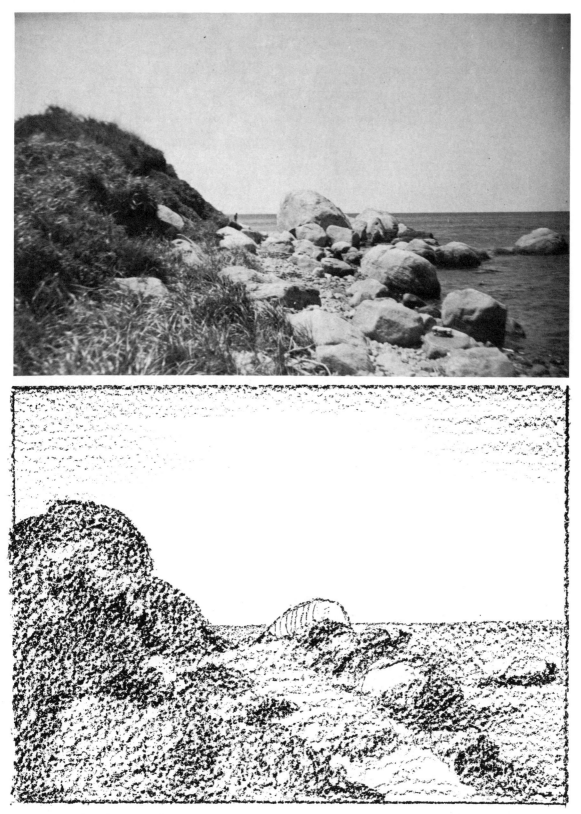

Vacation snapshots are raw material for practice in seeing landscape simply.

ing" which a camera does by mechanical means, and which the photographer does from experience. When the artist takes his position in a field, or beside a lake, and proceeds to sketch, his trained eye has already picked out the subject. He has studied it with a view to marking out on paper his main elements. The first rough lines which the artist draws upon his pad form the whole framework upon which he builds his sketch. But first he *saw* clearly what should go into the picture and what should be left out. He saw what features of the scene were of *major* pictorial value, and what were of secondary interest. He saw, in his mental mirror, the principal masses and lines, and the three or four main areas, in terms of black, white, and gray.

Study the illustrations here. You can get hours of valuable practice at home before you go out to sketch. As you learn to look at landscape, and to see an ordered composition, your sketches, as well as your quick "roughs" made from postcards or magazine photos, will improve. To visualize your main lines and masses before you begin to draw is to accomplish half your task!

Working from photographs in this way to train your eye for seeing landscape is not so easy as you may at first suppose. It requires skill in observing the primary design of the picture you copy. It calls for judgment in omitting details. But at this stage of your practice you should be able to do that with a photograph in about one-tenth the time it would take you to see the same masses and lines in a landscape out of doors.

Even after you have made a number of outdoor sketches, you will find much of real value in these exercises at home. Using photographic illustrations clipped from magazines, or postcards of simple landscape views, make a number of roughs such as you see here. Indicate in each only the broad divisions of the space; put in the main vertical and horizontal lines as guides. Try to shade areas to show the *relative* darkness of each part. Later you will be required to get much more precise effects.

A word of caution: in these copying exercises always use photographs with few details such as buildings, automobiles, or other foreground objects. Always mark with great care the *horizon*. It is a kind of backbone for your whole composition. Sketch the relative sizes of dark cloud masses, groups of trees, reflections, or mountains. Forget leaves and twigs. I will have much to say later about the anatomy of trees.

After some practice you will be able to look from a train window, or from your back porch, or from a path through a park, and reduce any given section of the view

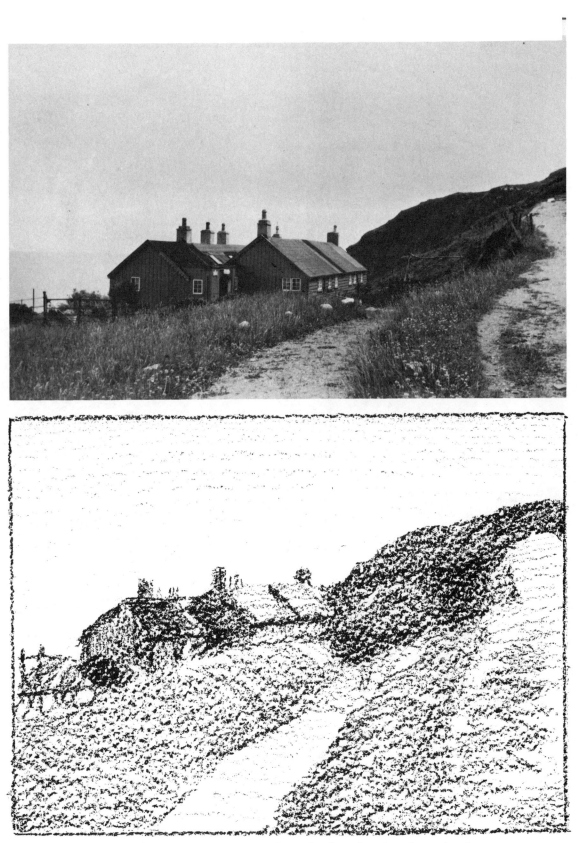

Postcard picture of seaside cottages in Ireland, reduced to its main elements.

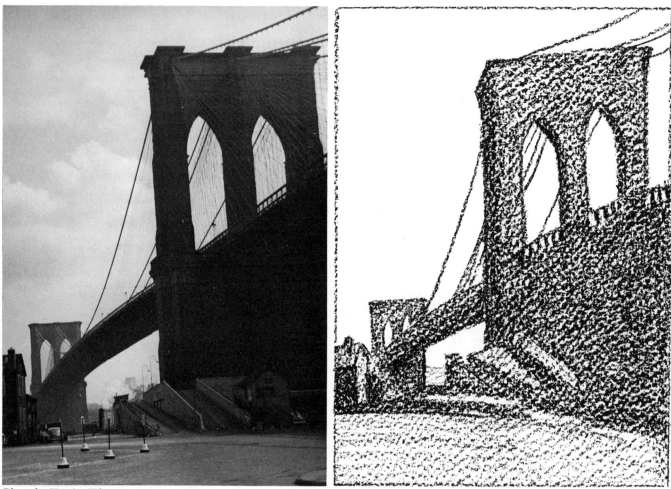

Photo by Harriet Wiesner

Even a massive city bridge can be drawn from a camera study.

in sight to broad forms, solid shapes, and *simple* masses of light, dark, and medium tones of your pencil. No amount of careful drawing and shading can make any outdoor sketch stronger than the "rough" you make of the scene. The finished sketch will stand or fall, in its effect, by what you see in the first six or eight minutes, and by what you draw in the first ten minutes.

Finally, but most important, do not work solely in outlines, or look at the landscape for sharp edges. An apple has a profile, and so has a hill or a tree. That profile is not an *edge*, but a round form seen in perspective. See the solid mass of a hill or a house; see the roundness and depth of a cloud, not the wiry outline which actually does not exist. Use the side of your pencil point, and as you copy a dark mass of shrubs

14

In this old house above the meadows lived an unseeing artist.

as it appears on a postcard, try to *feel,* in every line you make, the depth, or third dimension, which a poor photograph may not show.

WHERE'S ALL THE SCENERY?

The town in which I live is built upon a hill that rises on one side from miles of flat marshland, broken into stretches of meadow and river bank and field. The town slopes away on the other side to a river that flows into New York Bay. At the far edge of the town, overlooking the meadows, stands an old Dutch colonial house of red stone and clapboard covering. Though its fine original lines have been altered by

15

the addition of porches and sheds, the location of the house against a colorful background of flat land has made it a perfect subject for sketching. In the course of several years I have made many drawings, small oil paintings, and water-color sketches, with that house as the chief object of interest. I drew it from many viewpoints.

One day the elderly man who lived there limped across the field to stand behind me as I finished a sketch. He told me that his daughter liked to draw and asked if I would come over to the house to see some of her work. I followed him through the autumn grass and into the house. A small, pale woman with graying hair greeted us. At her father's request she brought out several pastel and crayon drawings. They were carefully done, but in a very artificial combination of colors. When I asked where she had found her subjects, she showed me two or three calendars adorned with cheap lithographs of landscapes and flower gardens.

"Have you ever tried sketching outdoors?" I asked her.

She gazed at me in astonishment. "Why, there's no scenery around here!"

I told her that for years I had been sketching her own house and the meadowlands beyond her front yard. Her face plainly showed that she thought I had queer notions of what was scenery.

Many times since I have recalled that little woman who had such an urge to draw that she copied in color every calendar print she could get. She had never learned to look at the beautiful view from her own front windows—the fields that changed color with the seasons, the clouds that floated above them, the trees that cast shadows along the borders of the fields. She had ability in using pastels and crayons and had improved upon the cheap prints she copied, yet nobody had ever taught her to *see* the beauties beyond her front-yard fence.

START LOOKING FROM THE ROOF

If you have not consciously or unconsciously trained your eyes to see the landscape in which you live, this is the time to begin. It is a skill worth learning well. There is pleasure in knowing how to use your sense of observation so that you can control your vision of the world around you. Suppose you start looking right in your neighborhood. If you live in a city or suburban apartment house and have access to a

16

flat roof, go up some bright day in the morning or afternoon and stand with the sun at your right or left hand. The view in front will be broken up into a dizzying pattern of light and dark squares, oblongs, and angular surfaces. Perhaps a few treetops will stick out above the sea of flat and gabled roofs and building cornices.

You are on the roof to see with a fresh eye something you have looked at from

A pattern of dark and light areas seen from a roof.

below until it has become commonplace. Attempt no sketching from your roof yet, however. Even an experienced artist would face difficulties in trying to choose a subject from the panorama spread out below and beyond a city roof. Your purpose now is to exercise your eye, keeping in mind those roughs you made from vacation snapshots of landscapes. Study the view from your roof in several ways:

First, select with your eye some higher building, half a block or so away. Observe carefully its general shape—like an upright shoe box, let us suppose. Note how that oblong block stands in relation to lower buildings and roofs around it. Try to see the whole arrangement in simple forms—blocks, squares, and other geometric shapes —just as though windows, chimneys, radio aerials, and similar details were erased.

17

Second, scan the *horizon*—the farthest ragged line of roofs. This gives distance to your view, and it fixes a limit to that distance. It marks off sharply the earth from the sky.

Third, study the "plain" of roofs that stretches from your feet to the taller building half a block away. Forget for the moment such technical matters as perspective. Notice only that the flat area of roofs in front of you is broken by cross ridges of walls, by chimneys, by skylights, and other upright forms. See how the light of the sun affects these broken areas, how anything which sticks up *vertically* from the table-like surface of a roof will form a darker slab, or strip, or mass—a shaded wall, or upright square column, darker on the side in shade than is the roof itself.

THE ANATOMY OF LANDSCAPE

Just as the human figure has a basic design—head, trunk, arms, legs—so the land, in its natural state, or when covered with water, streets, or buildings, has a basic design. It consists largely of a horizontal plane, or series of planes, from which rise vertical or sloping forms—hills, rocks, trees, houses, wharves, boats.

At first such a study of form may not seem easy to make where you live. There is too much to see from a roof! But when you go out into a field or a park, your study will be simplified. You will choose a main object of interest for your picture, perhaps a wooded hill rising from the field before you. The hill must be studied with care for its shape. Is it longer than it is high? Is it lopsided, one slope dropping away steeply, the other curving gently down to the field? Beyond the hill you may see a horizon line, ragged if it is formed by distant buildings or trees; long and curved if it is formed by a range of mountains or hills.

You will also notice how the foreground, not far beyond your feet, is broken by a few bushes, a small tree, some hillocks of weeds, or a fence. Observe with care how the light from the sky shapes these forms. Later we shall go thoroughly into many other interesting problems in simple form and apply the results to sketches. Now it is important that you practice training your eye to see the main lines, and large shapes and masses, of *any* landscape out of doors where there is a visible horizon. The details are fairly easy to handle. Unless your eye can be trained to *simplify* landscape,

18

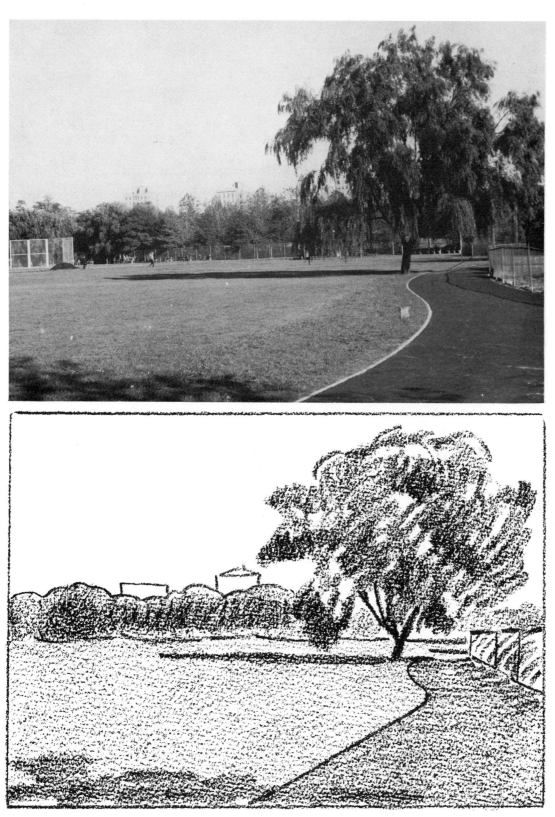

Your first subjects for sketching outdoors may be found in a park.

until you see plainly its basic design, its anatomy, the details will distract you and spoil sketch after sketch.

Before you get down actually to drawing in the park or on the beach, recall what should be clearly seen in any view you choose to study:

1) See the ordinary construction of the scene as a foreground plane beyond which rises one or several large forms.

2) See the relation of the horizontal, flat foreground, and the large *vertical* forms in middle distance, to the far horizon and to the sky. This relation is important, for it marks the divisions of your picture space. A house standing alone on a flat prairie, distinct against the sky, is about the simplest image you can imagine in landscape, but even that is composed of three or four divisions, or spatial areas.

3) See the general effect of *light* on a foreground and on all upright masses of trees, hills, buildings, or other forms.

TRAINED OBSERVATION

When you gain further experience in looking at an ordinary stretch of flat terrain from which rise walls or trees, it will be time to go into the exceptional or unusual conditions. You will then learn how to see, and to draw properly, the hill that drops away below you or slopes steeply up from your feet.

In one of his lectures Constable said that the art of observing nature was something "as much to be acquired as the art of reading Egyptian hieroglyphics." The beginner in sketching is almost certain to be baffled by the vast variety of shapes and forms in any outdoor view he selects to study. As he improves in seeing, by practice in drawing he learns how to perceive at once the large masses and *main* lines in landscape, and then to divide the space on his paper into a few simple, broad areas. In learning this, he learns what to omit.

He learns to suggest much with lines and forms of precisely the right character. A patch of woods, or a cluster of tall shrubs, is seen as a form that has a particular shape—one broad part lighted by the sun, and another broad part in shadow. Within the lighted area he can distinguish the halftone gray from the brighter spot which receives direct light. This whole mass of foliage can be suggested by a few well-placed

20

Foliage may be seen as a form shaped by light.

strokes of pencil. The beginner's impulse is to draw carefully the separate twigs, branches, and clusters of leaves. The trained eye reduces all these to one unified, rounded form *shaped by light.*

This training in observation and drawing out of doors, over weeks of practice, is rewarding. The sketcher develops skill in the observation of interesting places, and he unconsciously acquires a knowledge of nature which has uses beyond art. Also, a long period of practice in outdoor sketching in pencil or crayon lays the firmest kind of foundation for making woodcuts or etchings, or painting in oils and water colors. The painter who has mastered all the elements of *drawing* landscape can more easily concentrate on the difficulties and subtleties of color and technique, and with far more assurance than is possible to one attempting to learn at once both drawing and the application of paint.

The same training and practice in outdoor sketching leads the amateur artist to a more enjoyable appreciation of the drawings, etchings, and paintings of the world's master artists. After you have drawn from nature for a few weeks you will discover in the galleries of art museums many beauties and pleasures that never before had significance for you. In fact, you can learn much even now from a careful, intelligent examination of pictures by old masters and by contemporary artists.

There is no profound mystery about the technique of great artists. Their secrets

21

are not in old art books. The elementary principles which they applied may be seen, fairly plainly, in their original work—may be seen, that is, by those who know what to look for. It is true that the achievements of the old masters are not readily duplicated, even by experienced artists. But those achievements may be understood long before you have fully developed your own talent. As an illustration of the kind of examination of pictures which applies the ideas I have discussed so far, I am including here reproductions of two landscape drawings by Rembrandt, another by Thomas Gainsborough, the British artist, and a water color by John Whorf, an American artist of our own time. The notes which accompany these pictures are not intended to be art criticism, but are merely simple, practical analyses of the primary elements of sketching which this book expounds. I have used these examples to show that experienced artists, whether they lived a few centuries ago or are contemporaneous, evidently have seen landscape in precisely the way you are here advised to see it.

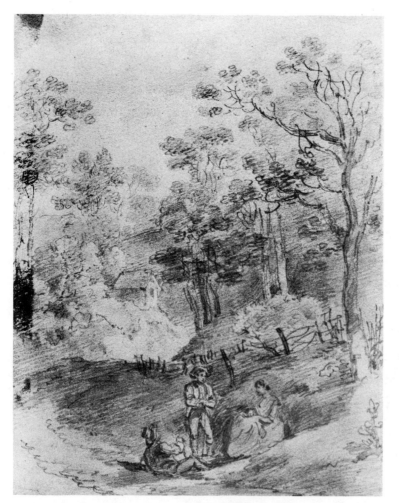

Gainsborough, in this pencil drawing, "The Moor," used a few large shadows for contrast with the lighter and distant hut and sand bank. Note the simple treatment of the trees and the interesting variety in foreground figures.

Courtesy of the Metropolitan Museum of Art.

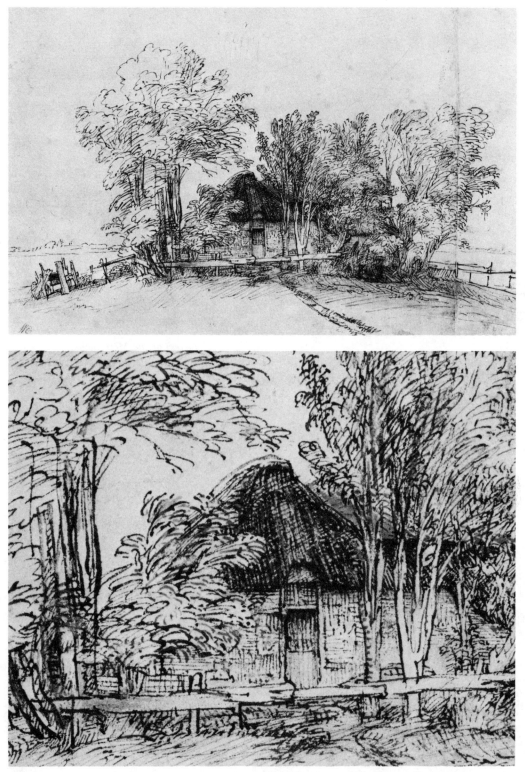

Rembrandt's drawing in pen and bistre (a dark brown water color), "Landscape with Barn," is designed as a large mass of light foliage with a dark central spot of roof. Note horizon line, and, in the detail below, the simple, rough treatment of trees and fence.

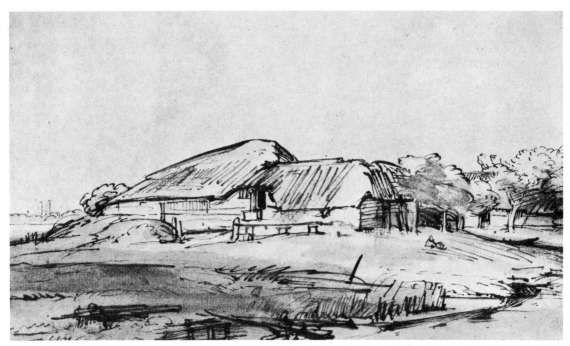

This drawing of farm buildings by Rembrandt is notable for a strong, though sketchy, foreground, and the sharply defined roofs, free of needless detail.

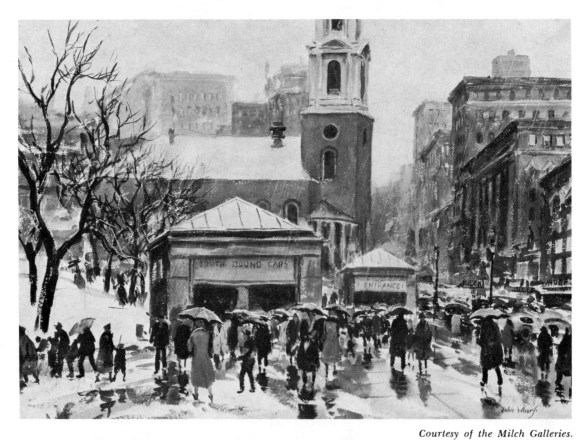

"Park Street in the Rain," water color by John Whorf, reveals how a trained eye sees figures and city architecture in dark and light masses.

II. YOUR FIRST FIELD TRIP
(No Gun or Guide)

THE TREE THAT GREW IN THE SUBWAY

A YOUNG New York advertising artist whom I know was attending a class in composition and drawing. The procedure was to invite some well-known illustrator to criticize the work brought to class by the students. One evening the advertising artist came with a rough sketch of a tree. The guest critic was Charles Livingston Bull, a talented illustrator who specialized in animal subjects. When he came to the tree sketch he said, "Now here is a drawing which has the genuine feeling of the outdoors, a certain warmth and freshness not found in some other sketches here—you drew it in the field, from nature, didn't you?" The student replied that he had made the drawing that evening while in the subway.

The explanation was, of course, that this student often had sketched out of doors and knew the anatomy of a tree from firsthand study, not from pictures in books. He had therefore drawn from imagination, or memory, something that was as authentic as a tree sketched from nature. No amount of copying others' drawings of trees can give the same quality to a sketch as you may get after working afield.

Ease in drawing landscape subjects usually comes only from long practice. Yet all landscape painters—even the foremost masters of that art—had to begin, had to make their first field trip, and depend on eyes and hand untrained in outdoor sketching. Most likely they came home dissatisfied, or downright disgusted with their efforts —and next day they probably went forth again, more hopefully, and more self-assured for having begun.

If you follow in proper order the sections of this book, you will get plenty of outdoor sketching by applying in the field the fundamental instruction and advice here offered. There is no substitute for that outdoor practice. You will have fun, and learn much, from making roughs from magazine photos or postcards, but that is no more than eye training. It helps, in a practical way, to prepare you for looking at

real landscape in all its natural colors and reducing that color pattern to compositions in tones of black, white, and gray.

In the field, whether it is a park, a vacant lot on your block, or the beach of a summer resort, you can learn principles of sketching which later you will be able to apply in exercises at home. Similarly, the drawings you make at home in your spare time from your field sketches or other material should be strides toward better work afield. From outdoor work you will build up a large collection of drawings that later can serve as raw material for woodcuts or paintings.

LEARN THE RULES, THEN BREAK THEM

Many who begin the study of an art soon wonder if the recognized masters achieved their place by following rules and formulas. A common suspicion is that the professors make up the rules after studying masterpieces by artists who never seemed to observe any rule. But that is not so. A few so-called "modern primitives" have successfully painted landscape with little knowledge of the principles—working by artistic instinct, if we may call it that. They often get remarkable effects, but haphazardly. It is easier and more satisfying for most of us to learn at least a few fundamental laws of art. Later, with good reason, and after much experience, we may knowingly break some of those laws if we feel an urge to strike out in original ways.

You will soon discover on field trips that it is not essential, for pleasure in your hobby, to study exhaustively the technique of painting landscape. There is no limit to which you may not go in that art, but from the first you will find boundless enjoyment in developing your ability to sketch well in pencil, crayon, and other simple mediums. That ability is, after all, the foundation of all landscape pictures except those made with a camera. Even some good photographers draw in order to learn composition.

Now we are ready to go out and make a real sketch. You have already been out on the roof, or in the park, or at the beach, to train your eyes in the art of looking at landscape. You should have learned by this time something of the skill of seeing the world outdoors with an artist's eye. Now you can begin to make roughs in the field, just as you made them from postcards.

26

NO FANCY BAGGAGE NECESSARY

For your field trips you will need a few simple working materials, but no elaborate paraphernalia. Your art eventually will be in your head, not in a box of pencils or paints. Put together a drawing kit, and *keep it all together,* for use on short notice, for quick jaunts to the park or to those fields at the edge of town. What goes into this kit?

Sketch pad. It is easier to handle than sketch books with heavy covers. It should be large, at least 9 x 12, or 12 x 16, of white paper, not lighter in weight than good typewriting paper and preferably heavier. Later you may buy large sheets of fine handmade drawing paper and cut them into suitable sizes for mounting with thumb tacks on a stiff board. At this stage avoid blocks of paper, colored paper, and paper with a very rough surface. Your pad should have a heavy cardboard back, firmly attached. Rubber bands are useful to hold paper and back together.

Pencils. For your first few trips use only soft black graphite pencils. Later you will enjoy experimenting with various types of crayon pencils, chalks, colored leads, pastels. But get along without those now.

Erasers. Kneaded rubber erasers are most useful. In addition, art gum or any large, soft, fresh eraser will suit other needs. Have several, and *use* them often. Frequent erasing is no sign of lack of skill.

A seat. You will find use for a light, strong metal or wood-and-canvas folding seat without a back. Some artists prefer a homemade wooden box, so designed that it can carry supplies and serve as a stool as well. Others insist that the only proper way to sketch out of doors is to stand at a portable easel. The theory is that you usually select a subject to sketch while walking around, then lose the right view of it when you sit down and see it from a lower position. Also, while seated you may work too close to your picture, especially if you are working in paints. But the answer is that some very fine landscape drawings have been made by artists who sat.

Finally, with a razor blade and a piece of cardboard backing from a pad, make a *finder.* It is a frame with the same relative shape as your sketch pad, but much smaller. Cut it so that the *inside* dimensions of the frame are about 6 x 8, or 5 x 7, and blacken it with waterproof ink. It is a useful aid to the study of any subject chosen for sketching. It is held in your outstretched hand, and moved up and down, left and right,

with one eye closed, until the features of your picture are selected and all other elements excluded. By looking through the finder at the actual landscape—not at your picture—you can check your composition and see the main lines in relation to the edge of your pad.

Prepare for considerable walking around. Half the fun is in finding the right subjects, for you can return to them several times and sketch them from various viewpoints. Your main problem now is to discover a subject neither too small nor too sweeping in size. If you sit on top of a hill, don't try to take in the entire valley below. I'll admit that it may be a beautiful "scene," but panoramas are a special art in themselves. That city teacher I mentioned in the opening paragraph of this book attempted his first water-color sketch from a roof and took in half the borough of Brooklyn! He soon learned how bad the result of such ambition could be.

The error at the other extreme, for beginners, is to sketch only one tree, one stump, one rock, one farmyard fence, one park bush. Later all these detailed studies from nature will have great value. For your first few field trips, however, it is wiser to choose a simple arrangement—perhaps a hill, not too far away; some shrubs or

Don't take in too much.

Look around for a simple arrangement of hill and shrubs.

trees; and a small field in the foreground. Keep out of the woods. Walk around in open fields or along a beach with few buildings. City parks usually have broad clearings, and open stretches of sloping grass, rocks, and shrubbery. These make perfect subjects for first exercises in sketching.

REMEMBER SHIH T'AO

One of the most enlightening statements of the way an experienced artist works at landscape sketching may be found in a little book published in 1935, *The Chinese Eye*, by Chiang Yee. The author describes a certain Shih T'ao, a noted painter of the Ch'ing dynasty, as a revolutionist in art because "he left both ancient tradition and modern influence to care for themselves, and danced, so to speak, to his own piping." Shih T'ao strove to reduce every landscape subject to bare essentials. In one "Snow Scene" by him there are only the contour of a distant mountain range, some bare trees, a hut, and a bridge. The result is powerful and simple—and good art.

Let us go out, then, on a sunny day when the air is still. The season does not matter as long as the temperature will let us sit comfortably in one spot for half an hour or so. I prefer the sunlight for beginning practice because it molds subjects into shapely, exciting forms. It creates dark and light masses that will make the very bone and sinew of a drawing.

Seek with care and patience for a subject that will enable you to sketch with the sun to your back and slightly to one side. Sit in the shade of a wall, hill, or large bush. When you have more experience you will know how to overcome the handicap of working under a cloudy sky or against dazzling sunlight. Usually the upper part of your body helps keep direct sunlight off your paper. Find a subject as simple as a beach or park affords. Choose one at first without buildings or other elements that require the drawing of details. Later we shall take up the problem of simplifying such features as barns, cabins, houses, factories, and even human figures as objects in landscape. What you need most now is subject material that will help you to make the *same kind of rough* that you did from magazine pictures or postcards.

KEEP THE SUBJECT IN VIEW

Let us assume you have found your subject in a park. Before you sit down to work, be sure you are looking at the most interesting aspect. Walk to the left ten yards or more, then to the right, watching the subject closely. Step back a few yards and note the difference, if any, in the arrangement of your field, hill, and tree. Examine the

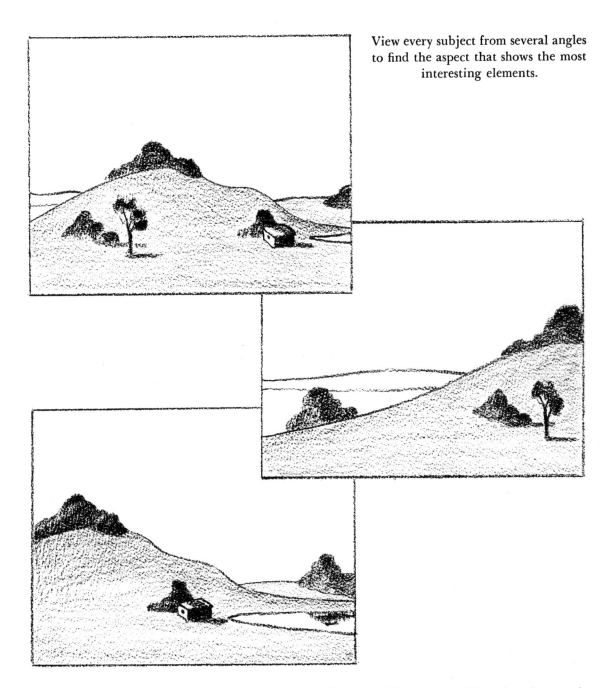

View every subject from several angles to find the aspect that shows the most interesting elements.

subject through half-shut eyes to see its *main* dark and light areas. Note in what position the large shadows and areas of light form the strongest, clearest pattern.

Keep any tall tree, or large mass of shrubbery, or the slope of a near-by hill, at one side of the picture. When you have surveyed your probable subject from every angle, set up the folding seat. Open your pad on your knees and look intently at the subject again. Don't be in a hurry to put lines on your paper.

31

Your subject may be somewhat similar to that in the illustration here which shows a foreground tree, grass, shrubs in the middle distance, and a hill for the horizon. Let us suppose you are drawing this.

By moving your finder, as you look through it with an eye closed, and as you hold it in an outstretched hand, determine where the tree would look best in the tentative picture. Will you center it? That might divide your picture in half. How would it look on the right? Move your finder.

Note with care how the row of shrubbery in the middle distance forms a curving dark mass, with a rather pleasing irregularity along the top of it. Now, put in this shrubbery first—just mark off on the pad the general shape and size of the mass. *Locate* this mass, with relation to the tree, and to the top, bottom, and sides of the finder and of your paper. Don't fuss over sprigs of foliage. Observe carefully how the full-bodied shrubbery marks the sloping line of the hill on which it grows. It shows the form, or structure, of the land there.

Lightly, but with sureness, place the trunk of the tree with a couple of upright strokes of the pencil. Remember, you are making a rough, not a finished work for the academy show. Mark the *shape* and *size* of the foliage on the tree with relation to the top and sides of your paper. This tree, and the shrubbery in the middle ground, will guide you in putting in the hillock at the left. Next, draw the farther line of hills. Perhaps in your subject it will be a distant group of trees, seen as a long, light gray mass in the background. Keep it in the background, making your strokes light.

Look again at the subject—not at your sketch—to observe exactly where the largest and darkest shadow comes. Then put it into your drawing roughly, with a dozen or so firm strokes of the pencil. The essential thing is to locate the main shadow at the precise place where it appears to come. In the picture shown here it helps balance the dark mass of foliage on the tree above.

Fill in the distant hills lightly, then bring your pencil forward to the foliage of the tree and indicate the darkness of its shaded part. Keep the main light patch white. Don't break up foliage into a jumble of spots and lines; divide it into *two or three* patches of dark and light. Draw no leaves or twigs. The line of your trunk and one or two limbs are enough. Your sketch—your rough, but correct, *beginning* of a sketch— is done. Work no more upon it. Promise yourself that you will make twenty or more

Draw first the line of shrubbery, then place tree and distant hill.

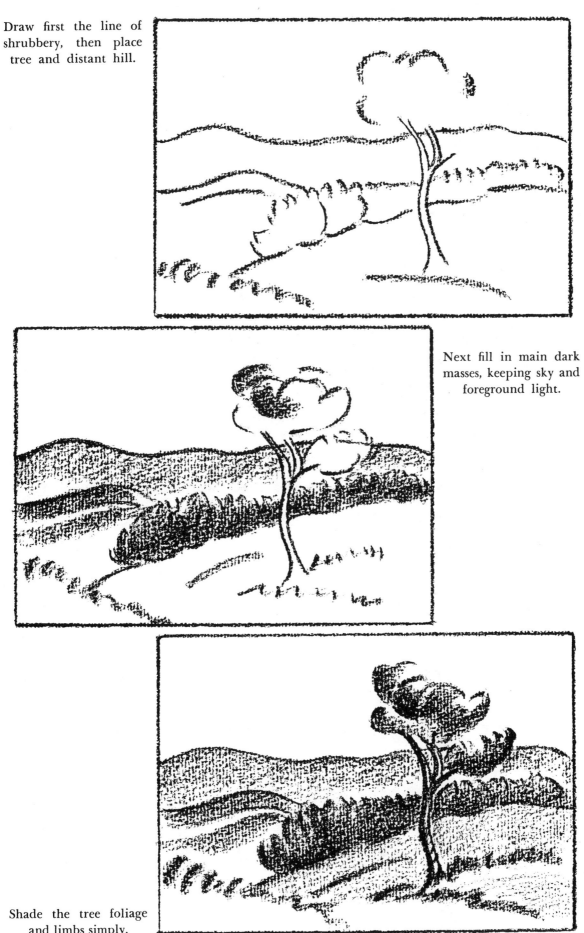

Next fill in main dark masses, keeping sky and foreground light.

Shade the tree foliage and limbs simply.

such roughs out of doors in the next two weeks or so. After you have made your tenth, you should be able to get fair results in fifteen minutes. You have then learned not only to see landscape, but to put it on paper in approximately the form in which you see it.

FORGET THE "GALLERY"

If a few curious passers-by have paused to watch you, don't be disturbed. It is probable that most of them envy you your tranquillity. Generally their questions are of no interest. When the first rough is done, discourage the "gallery" by rising and walking off with your seat and your pad. You have time to make another rough. Circle around with an eye out for a second simple combination, such as a bush, a fence, and some flat ground, broken by the shadow of the bush. If you are on a beach or lake shore that slopes up to a line of shrubbery or low dunes, you may find it most convenient to sit so that the water is behind you, or at one side. In a few weeks you can face the problem of drawing reflections in water. Don't discourage yourself now by attempting more than a simple sketch based on two or three natural features of landscape. A sloping sand bank and a tree or some bushes at one side make an excellent combination.

THE HORIZON PROBLEM

When you looked at photographs of landscape you took special note, I hope, of just where the horizon line was in each picture. Sit down in a field or other open place and, *with your finder,* study the effects of high and low horizons. Move the finder up and down, and note exactly the position, in the frame, of the line where the sky meets the farthest top edge of trees, hills, or distant buildings. Note how that horizon line *divides the space* occupied by your chosen picture subject. Ask yourself—should you leave a broad, high sky, and keep the horizon low? Or should you cut off all but a narrow strip of sky? The answer will depend partly on what other feature in the subject will also be cut off, at bottom or top, in placing your horizon. Try to keep all

34

truly interesting elements within the frame—even the side of a bush might help your arrangement at one edge of the picture.

Always sit far enough away from the main features of your sketch—a large tree, a hill, a shack—so that when you look at the entire subject through the finder, with one shut eye, the top of the tree or hill will not be crudely cut off. Moving the finder even half an inch can make a great difference in the design of your picture.

In every picture observe how the position of the horizon determined the main division of the space. There is no iron-bound rule for achieving perfect compositions in landscape, but every sketch you attempt will present this same basic problem of dividing the picture horizontally. That is why experience in the field, and constant study of good pictures at home, are the two best means of solving that problem.

You can learn much about the placing of horizon lines by constant practice, by doing several quick roughs of the same subject, with the horizon in each sketch at a different level. But you can also learn a great deal by examining the drawings and

In using a finder, take care not to cut off too much of the sky, tree tops, or a roof, or the fore-ground may occupy too much of your sketch, with loss of interest—as in this example.

paintings of good artists to see what they did with horizons. Every landscape painter had to overcome, in every picture, the primary difficulty of making a pleasing composition based in part on the position of the horizon. Look in art magazines or books for etchings or landscape paintings by Rembrandt, Cézanne, Van Gogh, Winslow Homer, Whistler, Inness, and by such modern Americans as Grant Wood, Adolf Dehn, Joe Jones, Jon Corbino, and Charles Burchfield.

THE SUN AS SCULPTOR

Let us try a simple drawing in the field which will illustrate another basic feature of landscape. Remember that when you looked from the roof of your apartment building, or from an upper window of the house, or across an open beach or a park lawn, you observed how upright objects were usually *darker* than the flat earth lighted by the sky.

When you sketch outdoors you are sitting near the edge of your foreground. A walk of perhaps twenty yards would bring you right into the middle of your picture, as it appears in the finder. The sun is behind you and to the left, so that your sketching hand does not cast a shadow across the paper. The objects in the section of landscape before you will be molded by light and shadow.

Your main subject may be the combination of a mass of trees on the left and a hill rising in profile on the right, with a shrub or two at the base, just to the right of center. (This somewhat mechanical arrangement is proposed here only as an example of outdoor lighting effects.) Observe how the field, almost like a table under a lamp, takes the full flood of light from the sky. The upright trees, taking the sun's light at an angle, will be darker than the ground, except where *direct* sunlight strikes the top or the side of a tree. Shrubs, too, are generally darker than the field in which they grow. The hill will show its roundness by appearing lightest at the top and fairly light along the slope that faces the sun, but on the shady side will be darker than the flat field below.

In sketching, therefore, exaggerate these lighting effects. For strength of composition it is well to be bold in showing the *form* of the ground, and the character and size of the vertical trees, buildings, or other objects rising from the horizontal plane.

36

The best position for the horizon, as these different views of the same subject show, may be determined by trial and error.

Feel the flatness of the lawn or meadow, the roundness of a hill, the bulk and depth of foliage molded into generally rounded shapes by the sun. Show clearly how the shaded wall of a house stands, roughly, at right angles to the ground, just as the convex side of a ship will rise darker than the water surface, even though it is colored by indirect light and by reflection from the water.

SEE THE MAIN DESIGN BEFORE YOU DRAW

There is usually an advantage in placing the large principal object in your sketch first. It is most likely to stand in the middle distance. Its form is more clearly seen because

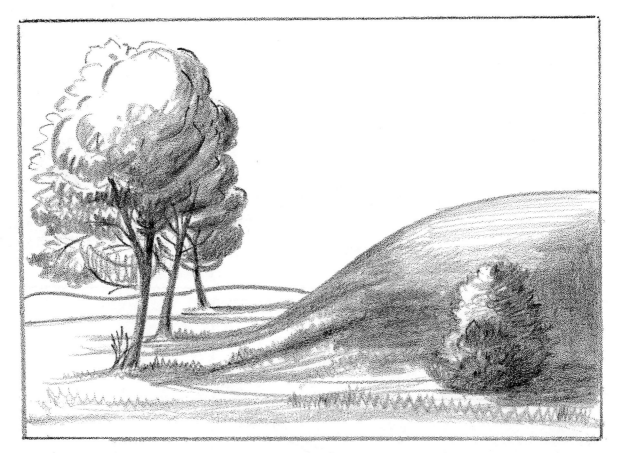

The flat field is lighted from the sky. The hill and the underside of trees may then be darkened in a sketch to mark plainly the rounded shape of foliage and rising ground, to indicate the bulk and form as "sculptured" by the sun. A hilltop, unless shaded by trees, is likely to be as light as the field below.

When the principal object has been placed first, other elements of a sketch may be located in relation to it.

of the way it is molded by light falling upon it and by the shadow it casts on the ground. Its proportions and size are clearly seen in comparison with smaller or nearer objects in the landscape. Other things in the sketch can be measured against that large main feature.

The position of the horizon must be indicated firmly. This, with the placing of the main mass in the picture, serves to mark out clearly the large areas of the sketch. One of these areas is the foreground. Beyond it stands the hill, or barn, or mass of rock chosen for your chief feature. Beyond that is the horizon and the sky. The horizon, of course, need not be a straight line, such as you see when you look off across the ocean. It may well be a line of roofs, or a distant line of treetops, or a range of hills.

Working in this way, carve out your rough sketch in large chunks. Refinement

of the whole design comes later, but can be successful only if the first rough arrangement is right. At this stage of practice leave out the clouds. Leave out scores of little bushes, tufts of weed, and many individual trees that clutter the stretch of landscape on which you have focused your finder. Work in broad masses, and feel the shapes of all the main forms—foreground, hill, shack, clump of trees.

SIMPLIFY!

Simplifying, easy as it may seem while you read this, is likely to raise the most difficult problem when you are in the field. There is nothing to be gained by kidding ourselves about that. Let me put down here, in plain terms, some advice to help solve that problem. Necessarily you will choose a landscape subject that I cannot here

This sketch is somewhat cluttered, and lacks clear design and emphasis on one object.

describe. The problem of simplifying is there, in any landscape subject you may choose, and it must be tackled by every student as one for him to solve on the spot. It will be solved in a different way for each sketch. But there are methods of arriving at success. Here is the whole process, summarized:

1) When you go out into a park or field or on a beach, and select a combination of natural forms, and look at it until your eye has picked out one principal feature of interest from all surrounding details, you have taken the first step in simplifying.

2) Look sharply at this chosen feature of interest, and, with your finder, *place it* with relation to the horizon.

3) Draw the main feature of the sketch in broad strokes, with the side of your pencil, lightly, to show plainly but roughly its shape.

4) Draw the horizon—all you can see of it on each side of your main object. Draw it across the picture, not as a straight line, but as a contour, simplified, of distant

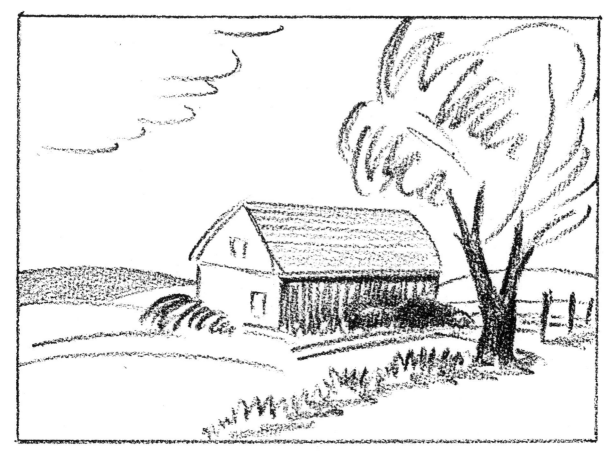

Learn to work broadly, omit distracting details, and bring out a principal mass.

treetops, or hilltop, or beach dune, or whatever it is. It will, of course, pass behind your principal feature.

5) Put into the foreground space of your rough sketch some minor feature, to one side or another of the main subject, but nearer to where you sit. It may be a small bush or a boulder. Darken the shaded side.

6) Next, darken firmly, in broad strokes, the entire shaded side of your main feature. Don't give a thought yet to delicate "shading," or to subtle gradations of shadow, or to small patches of light within the main shadow.

7) Put in the principal ground shadows, roughly, with two or three broad strokes, precisely in their place.

8) With rapid strokes of your pencil, fill in completely with light gray tone (not black) the *lighter* areas of your main object. I am assuming that this object—house or hill or whatever—rises from the flat plane of a field, which, as we saw, will be left light in tone.

Draw the main lines, including the horizon, before shading any part.

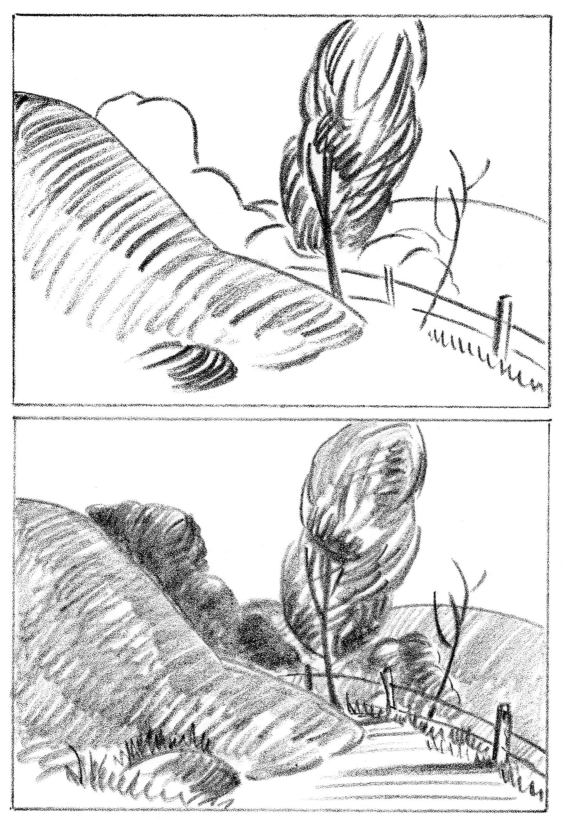

Darken the main features to define the composition before attempting detailed shading. Simplify the foreground.

Do a number of rough sketches marked by clear division of spaces.

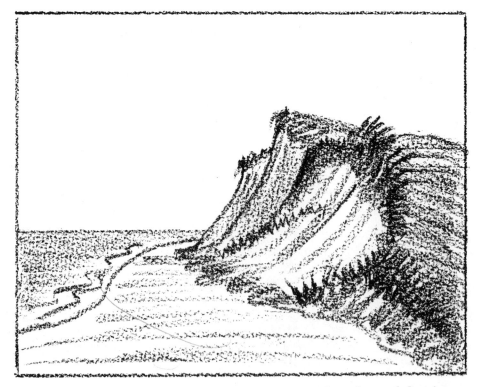

Save roughs and date them, to record your progress in seeing and drawing.

9) Shade the foreground lightly. Omit tufts of grass, twigs of trees, wisps of cloud. Don't be microscopic. Also, don't be telescopic, for then you will bring the distant hill or distant mass of trees too close to the foreground.

10) Stop when you have a rough. You should have caught the character of your landscape subject in the first ten or fifteen minutes. Work all over a sketch, and never develop one part beyond the rest.

Such roughs as you make on your first few field trips may have genuine beauty. They certainly have usefulness. Date them, save them, and measure your progress in this art of drawing simply what you have learned to see simply in landscape. Your future skill will develop from such a firm foundation.

III. GROUNDWORK INDOORS FOR OUTDOORS

"MUSCLE TRAINING" FOR SKILL

ANYBODY who hopes to master the piano, or even to play for the fun of it, soon learns that practicing scales is part of the course. A boxer carries the same idea further: even after he has trained himself to outpoint any opponent of his weight, he knows that bag punching has its uses. What you now come to is pretty much like running through scales, or hitting a bag, to develop co-ordination of hand and eye. Here are some indoor exercises:

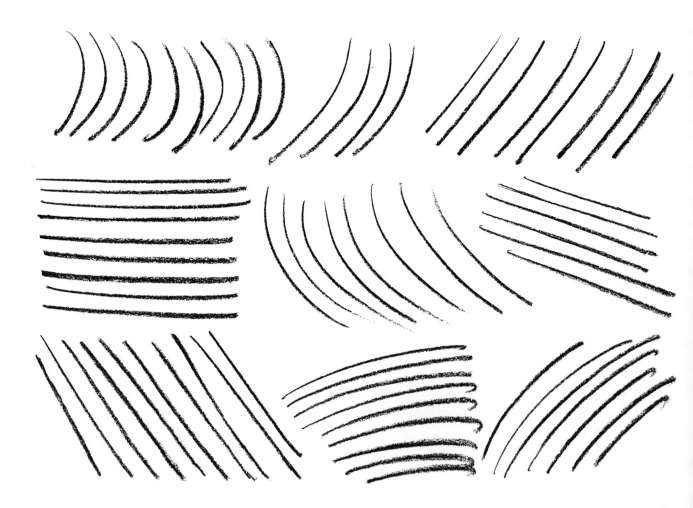

Practice drawing the massive solidity of a hill or bank.

No doubt you have often practiced the drawing of many kinds of strokes with a pencil or pen. It is a highly refined form of muscular exercise, and you cannot do too much of it if you intend to enjoy, with a sense of sureness, the pleasure of sketching from nature. For one thing, constant practice in making lines straight and curved, with a crayon or pencil, helps improve your speed in technique. That is a useful skill in drawing outdoors under conditions in which the light changes steadily with the course of the sun.

Tack a large sheet of any kind of smooth paper to a drawing board and, sitting with the lower edge of the board in your lap, and the board itself resting against a table edge, let your drawing hand swing free curves in pencil strokes across the top. For the next row try slanting strokes, down from right to left. Then do horizontal strokes six inches long and close together, but not touching. Practice every sort of

curve, trying for a steady hand and a firm stroke. Increase the speed—but only gradually.

I have stressed the importance of looking at landscape and drawing it in terms of bulk and mass. If you are sketching a hill that rises from a meadow, try to construct that hill on paper as though you were aware, every moment, of the great weight and bulk of rock and soil which form it. Feel the solid, massive roundness of the hill, and get as much of that into your drawing as you can. Make every stroke mark the full "girth" of the rising ground.

There are simple ways of improving at home your skill in sensing the bulk of the earth's natural formations—rocks, river banks, hills, slopes, the shoulder of a sandy beach, or the side of a mountain. For instance, find a rough stone somewhat smaller than your head, carry it indoors, and set it on a table with a sheet of paper behind it for background. Let the light from a lamp fall on it from one side, and sketch it from about four or five feet away. Give slight notice to details of surface—the little knobs, cracks, dents, and stains that mark the "skin" of the rock. Instead, try to draw it in such a way that you indicate its thickness and weight. Some old masters used stones in this way as models.

Build your drawing around three imaginary lines: one passing through the center of the stone from top to bottom; a second passing through the center from side to

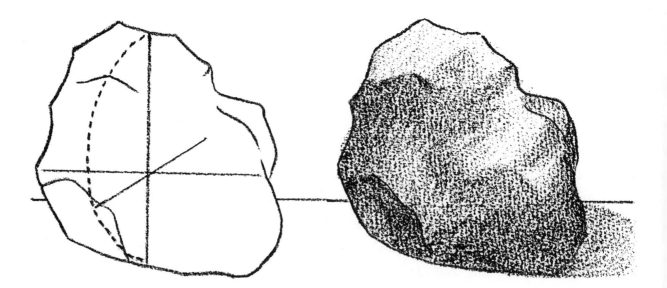

side; and a third crossing these two in the center, because it passes through from *front to back*. Draw these lines lightly before you draw the stone. They will appear like a wire frame on which you could build an imitation rock with clay. The line from front to back may give you some trouble, because it will be foreshortened, seen from a slight angle. But use it to get depth to your drawing of the stone. Shade the

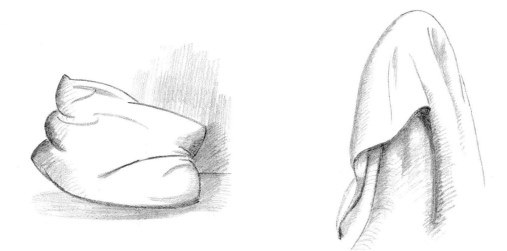

sketch very roughly, only enough to add to the illusion of bulk and weight which your sketch must have to be right. You are not trying to make a pretty drawing with fancy shading, but to study at firsthand a part of the earth's foundation.

CURVES AND ANGLES

The ruggedness of rock is not the sole characteristic of the earth's face. There are gentle slopes, rolling hillocks, sand dunes, and the flanks of mountain ranges covered with foliage that softens the ridges. Borrow a sofa pillow from the living room, and throw it upon a table that stands against a wall, so that the bulk of it sags in places. Try to sketch it in outline. Suggest its soft fullness with little or no shading by getting the curves right in bare line. It offers a challenge to your skill in drawing accurately something that looks easy but isn't. You will recognize similar curves and rounded surfaces on a vast scale in landscape. Don't be satisfied with one rough sketch of a pillow or cushion; draw half a dozen, in *outline,* until you can bring out on flat

paper the illusion of a full-bodied, curved surface broken into interesting angles.

Another way to study the highly individual character of curves is to drape an unstarched shirt or other piece of thin, soft material over a table lamp or statuette. With a freely swinging wrist and elbow, draw the down-sweeping, tubular folds of the cloth. This should help you to develop a more sensitive feeling for the differences in curved lines. It is of practical use out of doors when applied to the curve of a tree branch, a spray of shrubbery, the curve of a sail, or the long line of a slope on your horizon. But note the most important fact: the lines of the folds in your shirt draped over a table lamp are not like wire, but are the outlines of forms that have depth and

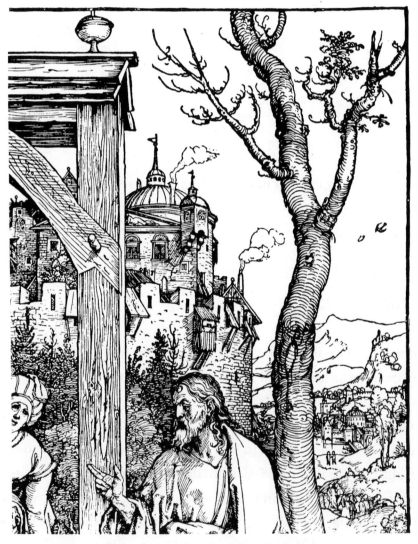

Part of a woodcut by Albrecht Dürer.

perspective. The rolling, tubelike folds of the hanging cloth have not only width and length, but a third dimension.

For one example of a technique by which such third dimension is drawn realistically on flat paper, examine a section of tree done by a master of line drawing, Albrecht Dürer. The trunk and limbs shown here were taken from a woodcut. Observe the way in which that artist curved his lines to follow precisely the cylindrical form of a curving branch. Had he drawn the lines lengthwise, along the branch, the impression of a rounded, solid form would not have been so strikingly given in that detail of the picture.

ROUGHS FROM THE MASTERS

A strong pattern of dark and light forms in a sketch is not usually hit upon by chance in nature. All the practice you can put into composition will be rewarding, for the results will appear in steadily improving work.

Drawing made from reproduction of painting by Constable.

If you were to walk into a gallery of paintings, stand in the center, and scan quickly all the pictures on the walls, certain canvases would arrest your eye and convey a strong sense of design. This usually is the source of much of the pleasure that well-composed pictures give. The principles of composition can be illustrated clearly. The illustrations given here are pencil drawings made from reproductions of paintings by Constable, Rembrandt, Manet, Ryder, Seurat, Winslow Homer, Van Gogh, and Cézanne.

The Constable is built upon the dark mass of hedge which runs from the lower left toward the upper right corner. There it rises sharply into the massed foliage of trees. The form of the hedge is clearly marked off by the light on the road at the right and by a rolling field which drops away to the left, where in the distance are long ridges and wooded slopes. A white cloud across the sky gives contrast to that area.

The Cézanne composition is heavily architectural, and of interest for our purpose because of the broad treatment of the major masses. The wall and buildings on the

A copy in pencil of a Cézanne painting.

Rough drawing from Rembrandt's etching, "Three Trees."

Drawn from reproduction of Seurat's "The Setting Sun."

left, with their lines running acutely toward the distant end of the street, form a powerful dark mass rising abruptly from the roadway. The walled-in effect of the place is thus plainly indicated. The entire internal design is made stronger by the high expanse of sky and by the tower.

In the Rembrandt the silhouette is even more strongly marked, the dark mass of bank entering the picture from the right, and the bright sky occupying most of the upper half, with a dark cloud in the upper left corner which helps balance the mass of dark ground.

A more modern type of landscape design is Seurat's "The Setting Sun," which shows the slope of a shore line dropping from left to right and leading the eye down to rocks and a small cove. The originality of this composition lies in the painter's use of upright posts and piles to break up the gray mass of breakwaters and in the streaks of cloud, which similarly add variety and interest to the sky space.

The Ryder seascape is characteristic of that American painter's manner of dividing his picture into a very few sharply contrasting dark and light areas. The actual

Drawn from a composition by Albert Ryder.

Drawing based on Van Gogh's painting, "Bridge at Arles."

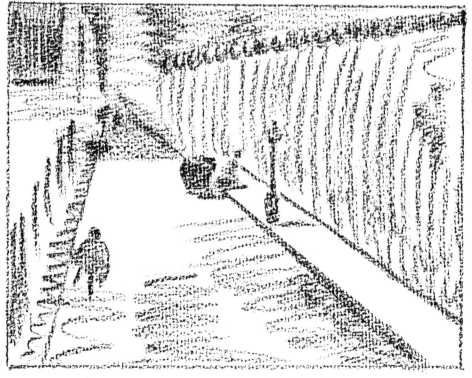

Rough from a street scene painted by Manet.

horizon is low; the two dark masses that cut across the picture, above and behind the sailboat, are clouds.

A more serene and much brighter mood is evoked by Van Gogh's "Bridge at Arles." The rough drawing shown here indicates how the upright dark trees are balanced at the lower right corner by the line of grassy bank. These two dark features are perfectly related and connected by the horizontal and much lighter lines of the bridge.

Manet's "Rue de Berne" carries out, with some exaggeration, the same use of a road as seen in the Constable. The street is of interest, first, because it crosses the picture at an acute angle; second, because three dark spots—two figures on the left, and a carriage on the right—break the main lines and arrest the eye. The vertical walls flanking the street help give depth to the composition. The dark oblong in the upper left is a sign on a building.

In the composition made from Winslow Homer's painting, the foreground is a large grayish mass of dune broken sharply by the dark shrubs. A figure is almost silhouetted against the light strip, which is rough surf. This figure is so placed, and so well emphasized, that the eye is caught by it first, moves to the left along the pointed light strip of sea, then downward sharply to the lower right corner. The contrast in tones—a dark sky above the waves—and the diagonal lines of the dune, add motion and a sense of conflict to the design.

SOME BASIC PRINCIPLES

From a study of such compositions you may derive certain guiding principles for direct use in your own outdoor sketching. The first idea you may observe in the design of these paintings is to divide a picture into a *few* large related units—masses and areas. No sketch can possibly be much better in final effect than you make it in marking off, in your *first* rough outline, the two, or three, or four main parts, or divisions, of the picture space. If these few major units are not clearly conceived *before* you draw a line, and if they are not clearly shown in the first stage of the sketch, then the details may easily run away with your design. In your first ten or twenty sketches, therefore, several attempts may be necessary in every case before you are successful

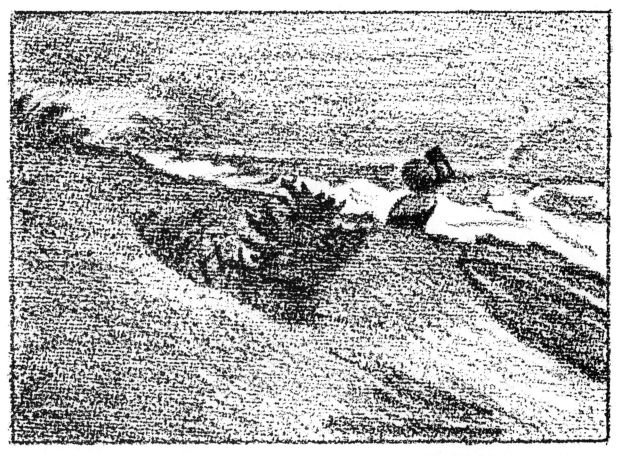

Drawn from a reproduction of Winslow Homer's "West Wind."

in reducing your chosen landscape subject to a few main areas and forms. No matter how difficult you may find this problem, it is worth every ounce of effort you put into trying to solve it in every picture you make. A sketch which you begin by putting down a number of trivial details is almost sure to be weak and hard to save from confusion and scattered interest.

Look again at the Winslow Homer "West Wind" with the figure standing above the surf. When the artist made his preliminary sketch for this painting, it is almost certain that he began by drawing the line of hill downward from left to right. That immediately divided his entire space into two unequal parts—a desirable first step. Next he probably drew the horizon, to indicate the far skyline of the narrow strip of sea. This made a third area, different in size and shape from the other two. He then may have put in the figure, trying it in several places before deciding upon its position on the slope. One function of the dark foreground shrubbery and grass is to show

more plainly the steepness of the slope. Also, these dark blobs help to keep the figure back in middle distance. The effect is dramatic and full of motion. Another purpose served by the shrubbery is to break up the dull, flat, grayish tone of the slope.

HOW TO LEARN COMPOSITION

For practical use in field sketching, the rudiments of good pictorial design or composition should be learned by anybody who wishes to get the maximum pleasure from this art. It is not possible to become a master of good composition in a short time. Indeed, even some experienced artists never seem to be able to apply the basic principles of composing masses and areas into the best possible arrangement. But the process of learning how to divide your picture effectively, and how to place within it the parts

Courtesy of the Metropolitan Museum of Art.
"Old Domingo Mine," water color by Philip L. Dike, contemporary American artist. It is shown here for its interesting arrangement of dark and light elements. Notice how the lines of the composition lead the eye into it.

of your sketch, omitting what does not add to the main design, is a source of deep pleasure. There are several ways to go about learning:

1) Borrow from a library, or buy, several art magazines devoted to news and criticism of new exhibitions. Study with care the black-and-white reproductions. Compare one picture with another. Note precisely how the dark and light units in a painting are placed within the space. Try to detect ways in which a picture could have been improved, perhaps by omitting a needless figure, tree, or other form, or changing its position. Look especially in every landscape picture for the position of the horizon. Magazines for amateur photographers also have pictorial material deserving of study.

2) Give similar close attention to reproductions of the paintings of old and modern masters found in art books, art catalogues, and histories of art. Copy the best of these pictures roughly. Rule off a sheet of paper into half a dozen oblongs about 3 x 4½ inches, and fill each of them with a composition copied directly from a painting as strong and simple in design as those illustrated in this chapter.

3) Attend art exhibitions and visit museums often, to study effective landscape drawings and paintings. Try by eye to "translate" the color compositions into black, white, and gray, picturing to yourself how each would look if copied by an artist who used only gradations of black and white.

Constable, when he was a student in London, wrote home to a friend, "I shall not have much to show you on my return, as I find my time will be more taken up in *seeing* than in painting." He was then visiting art galleries to study the work of Dutch landscape painters. Whether or not you are able to get to galleries, try to look at hundreds of book and magazine illustrations of works of art, and at works of art themselves, and enjoy the study of their compositions. The benefits of such observation will be felt increasingly on your sketching trips afield. Certainly it is not imitation you need, but understanding of the reasons why the artist, in each case, divided his space as he did and placed his trees, buildings, or figures precisely where they appear. Every painter had to face that problem in his first pencil sketch of a subject, and if he failed to solve it well, the failure was carried right into the finished oil or water color.

IV. ANOTHER FIELD TRIP
(With a Few Complications)

AN ART FOR PEACE OF MIND

FISHERMEN say that a supreme source of joy in their pastime is the opportunity for solitude. Henry David Thoreau, living alone beside Walden Pond near Concord, wrote, "There can be no very black melancholy to him who lives in the midst of nature, and has his senses still." Anybody who can go into a city park early on a week-end morning and sit quietly on a bench will enjoy, in some measure, a chance to see the trees, the grass, and a stretch of ground in an atmosphere of calm. The very first step in the fun of sketching is to cultivate the habit of sitting relaxed and alone out of doors for a little while before you begin to draw. In those few minutes you will see more of the true character of nature in your own particular neighborhood than

you ever noticed before. I read of a painter who sat so still while working that one day he discovered a field mouse in his coat pocket.

Passers-by who pause to peer while you draw are not always nuisances. One spring morning several years ago I was sketching on the shore of the Passaic River in

a small patch of woods when a man who obviously was a laborer sauntered over to stand behind me. After a moment I made some remark about the weather and was surprised when, abruptly, he said that my drawing seemed faulty in one detail. I admitted it needed correction there and wondered at his observation until he told me that he worked in a lithographic plant and associated much with artists. He had a

sharp eye for perspective and for gradations of light and shade. Suddenly from his hip pocket he drew out a bottle of sherry and offered me a drink. Few kibitzers are likely to be so helpful or kindly. If you try to argue with those who are nuisances your sketch will suffer.

Also save yourself irritation and waste of time, incidentally, by carefully checking your necessary supplies before you leave home. I keep together, in one small, light case, all I need afield for drawing. If you would guard against forgetfulness, make a list of working materials and tack it up where it will be seen just before you leave the house. Besides your pencils, erasers, drawing pad, and folding seat, have a few rubber bands to hold your drawing paper in the breeze; a folded newspaper for covering damp ground; and a flask of drinking water. Go forth, as one Chinese painter advised, "untroubled and joyful," and forget the ordinary worries of life. But don't forget your eraser.

MULTIPLY THE INTEREST

Let us suppose now that I accompany you on a field trip which has a primary purpose— to get enough of the right kind of sketching experience in a day's outing to advance

Sky and foreground areas can be made more interesting by a few curved lines.

your ability in two respects. These are: to discover several ways to add interest to a simple rough sketch; and to increase your skill in perspective and in "translating" natural colors of landscape into their pictorial equivalents in shades of gray.

Have you made at least a dozen roughs out of doors—sketches no further developed than that shown here? And have you made at home a dozen or more small simple compositions, copied from reproductions of paintings or drawings by some masters of landscape? In each case I assume you have chosen to copy the "pattern" of a scene free of complex architecture or other details requiring much skill in drawing. You have learned to study views that are composed mainly of a horizontal, more or less flat stretch of ground—a meadow, lawn or field—and an upright or sloping form, or several forms, such as a hill, trees, a fence or wall, and shrubs.

To these simple elements you are now ready to add several other common features of interest. One way to give more form to compositions is to break up a flat

foreground. This is done most easily by drawing a few ridges of earth, or strips of rough grass or weeds, across the foreground. If you look closely at the apparently level ground just in front of you, you may observe several long streaks of bare soil, or grass in shadow, or strips of grass darker than the general tone of the foreground. A series of ridges or ruts may lie across the foreground not far from your sitting position. These usually are most noticeable in the early morning or late afternoon, when the sun may cast a shadow along one side of each rut. They are easily drawn as a series of long, gentle curves of *varied* length, made with the side of the pencil point. Later, when you practice with colored pencils, you can run curves in brown, green, or yellow, in broken strips, among your black lines crossing the foreground. You must try to draw such ground ridges at a slight angle, so that they run somewhat into the picture and add depth to it. But it should not be too sharp an angle; they are part of the ground and must appear to lie horizontal, not rise into space.

In addition to the foreground of a sketch there is another large area which usually seems flat and lacking in interest in the drawings of beginners. The sky, which may occupy as much as two-thirds of your picture space, may seem dull in your finished drawing unless you break it up, even lightly. It is often one of the most important elements in a landscape composition, even when it is free of clouds. Drawing clouds well is an art in itself, and we shall come later to the pleasures and problems of sketching cloud formations in proper perspective. At present you may experiment by drawing a few lines and curves, softly, with the side of the pencil, to darken an upper corner of the sketch or add interest to an expanse of white paper which seems vacant.

FOREGROUND ROADS

Still another device for building interest into any fairly simple landscape drawing is to include a path or road that runs from the bottom edge, in a curve or an almost straight line, into the distance. Recall the Manet street composition. The only difficulty to overcome is to keep the road on the ground, in correct relation to your horizon line.

One simple diagram should be kept in mind. Let us suppose that we are standing at the edge of a broad, flat field, and half a mile away is a low range of hills. Consider the plain or the field as a vast tabletop, across the farther end of which lies a rounded

fold of tablecloth to represent the hills. The near and far edges of the tabletop may be seen and drawn as horizontal and parallel. The sides may be drawn as converging lines. Practice drawing dozens of these figures from several angles. Put in the hill at the far edge of each and shade it with curved lines to get a sense of rounded bulk, as

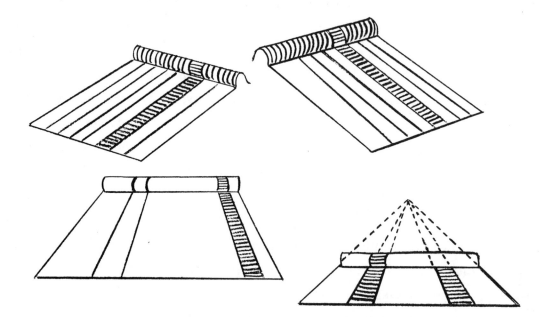

compared with the smooth, flat plain. Then cross the tabletop land with a few straight lines running from near to far edge. Any pair of these lines could represent the sides of a road running into your picture, as far as the horizon.

If your plain is tilted, as in the first drawing here, and if the road appears like the shaded strip, then you, as observer, are looking down upon the field from a height. If, however, the plain is drawn horizontal, as in the other figure, then the road passes close to you and on the same level. The far end of the road—or the farthest point you can see—will be on the hill. The horizon will be the hilltop.

Now let us walk along that road to the base of the hill. Notice as we go how the fence posts in a row climb the hill ahead of us. They go over the top and, presumably, down the other side. They remain *vertical*. A vanishing point on the horizon is no longer useful. It must become higher, for on the hill the converging sides of the road rise ahead of us. If continued into space, they would meet in the sky at some distance ahead, *above* the horizon. Draw an uphill road to show that.

We walk up the hill, and from the top we can see the opposite effect. From where

64

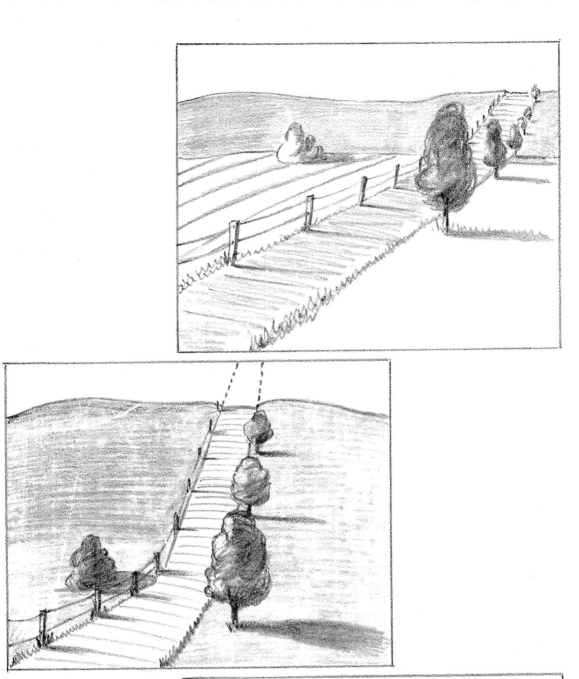

we stand the converging lines of our road drop down steeply. If continued to a vanishing point, they would meet *below* the horizon.

It is not necessary to go into the wide-open spaces to study these few simple principles of linear perspective. You can see the same converging lines by standing on any streetcar or railroad tracks. They are graphically shown in these photographs, which were taken from below and above an elevated railroad. The lines of supporting

pillars seen below the structure recede, the pillars remaining vertical but apparently growing shorter. Those in the distance seem to stand closer together. Posts or trees running off in rows *to right or left* also seem to shorten with distance and to stand closer together.

By constant practice you can learn to draw a curving road that runs from the lower corner of a sketch toward the horizon. The precise effect is worth striving for, as the interest in your finished drawing may depend considerably on the lines of such a seemingly simple thing as a road bordered by trees or bushes. If this road turns, keep in mind the vanishing point on the horizon. All parts of the road converge to that

*Photographs by
Norris Harkness.*

point except the parts crossing at right angles to the converging sides, as in the angle of road shown in the diagram on page 66.

BARNS, SHACKS, AND CABINS

Another common, yet important, means of adding interest to a landscape sketch is to include a barn, small house, or shack. Find one to work from, of course, in your roaming about the fields or beach. A building need not be architecturally complex to be interesting. As your experience is widened in outdoor sketching, you will find untold pleasure in making what may be called "portraits" of old houses, barns, mills, and factory buildings—detail drawings done for practice, and done also with an eye to later use in woodcuts, paintings, or other work. Such drawings are sources of information, based on your personal observation of the design of a particular kind of barn or house in your own neighborhood or vacation spot. But for our present needs, attempt nothing more than plain outbuildings on farms, or workmen's shacks in parks, or beach cabins. From these you can learn plenty about roof lines, chimneys, angles, and gables. Approach them exactly as you did the natural features of the landscape, see them in *blocks* and masses, without bothering, at this stage, to draw windows, doorways, porch steps, or other details.

If the drawing of barns or sheds gives you trouble, here is an exercise for rainy days at home: Set up an oblong candy box, or shoe box, with the cover on, and draw it from many angles, under a light so placed that one or two sides are always in shadow. Draw it until you feel completely at ease in putting down its lines and blocklike form from any viewpoint. At first your sketched boxes may look warped, as though they had been out in a bad shower. Soon your skill will develop as the planes of the top, bottom, and sides are precisely related, by careful study of their perspective and of their form in light and shadow.

Next, open a book, set it on the front edges so that it stands like a tent, and draw it from front and sides. Omit fancy shading; give the time to a study of the lines and shape, not the accidents of shadow, which vary according to the kind, distance, and strength of the light you use. This may seem childish stuff until you discover that a few hours of careful practice in drawing the covers and triangular ends of a book can

68

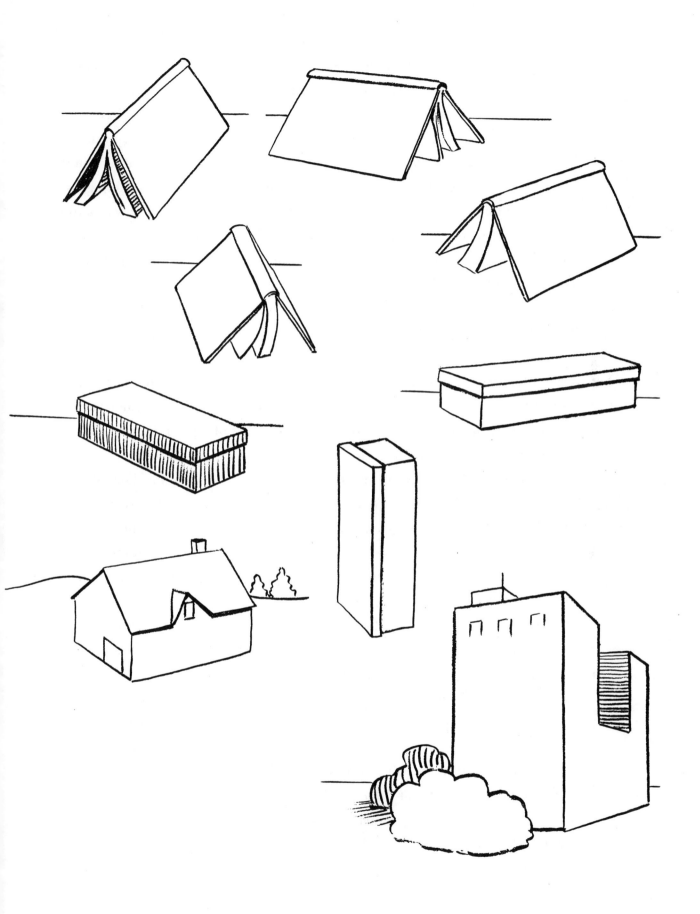

make the perspective of a gable-roof cottage much easier to draw. Candy box and book together make the basic form of most houses. It is not necessary to draw these objects in combination, however. If you master their perspective separately, that will give you the groundwork for drawing the walls and gable roofs of almost any simple building.

So much for the lines of houses, for their *basic* design under any lighting condition. If you intend to become expert in drawing actual houses in full "modeling," as they appear in sunlight at different hours of the day, observe constantly how shadows are cast by gables, window ledges, and chimneys. You will find advice and suggestions for such intensive study in Chapter VI. Another, more fundamental matter now requires attention.

NEAR, FAR, AND IN BETWEEN

Let us stand for ten minutes in an open space in a park or on a beach, and observe nature's own "stage lighting." A sketcher working with a pencil must understand at the outset that he will see many interesting pictorial effects of light, mist, or color out of doors that he cannot possibly attempt to put on paper except in water colors, oil paints, or pastels. But this does not mean that gradations of color and light should not be sharply observed, remembered, and translated into shades of gray. Now we shall suppose that we see before us a green lawn, or a light tan strip of sand. About a hundred paces or more from where we stand are dunes, or cottages, or a clump of park shrubbery. Beyond that, in what will become the distance in our sketch, may stand a row of trees, or treetops, or a hill.

Our immediate problem is to look at such a landscape and, by *comparing* the varied tones of green, yellow, brown, lavender, or deep blue—such as we see in shadows—picture the whole pattern in gradations of black and white. Neither black nor white is common in natural landscape, but every shade between them is represented. The task of recognizing those shades is one of the most challenging you are likely to face in the entire process of sketching out of doors. But a sensation of pleasure comes from gaining skill in drawing accurately all the subtle tones, from the darkest shadow to the brightest patch of direct sunlight.

It is always possible that there may be two or more important forms or areas in your picture which appear in the real landscape as of equal depth of tone, as rivals for

Although a black pencil cannot produce all the subtleties of color and atmosphere, it is possible, by practice, to learn how to get form and the effects of space into graded tones of gray. Emphasis in the dark or light parts of a sketch is essential. The unshaded paper may provide a clear sky.

the darkest spot. But these should not be shaded to an equal depth. Give emphasis in the sketch to *one* well-placed object or area by keeping slightly lighter or darker all other parts of the picture. If your emphasis goes to a feature in which your *lightest* spot occurs, you may be able to use the unshaded white of the paper at that place; therefore, at no other place in the sketch should such a large light spot be left.

As you will work on white paper at this stage of practice, your brightest area in the finished sketch may be the unshaded paper itself, or a part barely shaded. Most likely it will be all or part of the sky. Your darkest shadow is probably found on the shaded side of a house, or on a tree trunk. It is helpful to put in that darkest "dark" distinctly, as soon as the outline of the sketch is spread across your paper, when all of its parts are plainly shown, though incompletely shaded. It is not likely that your darkest dark will lie upon the foreground in a horizontal strip. Most of the ground

71

receives light enough from the sky, even on dull days, to dilute the *ground shadows* of trees, buildings, or other upright forms. The largest and darkest shadow might well come not too far from the center of the sketch. After it has been put down strongly on the paper, it serves as a guide, or color gauge, for all other *dark* areas lighter in shade.

Similarly, your *lightest* spot can serve in measuring the pale shadows, and the tone of distant treetops or reflections in water.

A CHART FOR VALUES

Draw a circle about three inches across and divide it into six equal parts. Blacken one part with a soft pencil, shading with an *even* tone all over. Leave the next section

By observing with care the precise size and position of the darkest shadow in your subject *before* you begin the sketch, you establish a yardstick for measuring all lighter or darker tones. On the opposite page are shown two possible ways to emphasize a large area—by leaving it light, surrounded by darker tone, or by leaving the area around it lighter.

white. Then carefully shade each of the other four parts with a *different* tone of gray, so that they range gradually from the black to the white around the circle. No two should be of the same value. Repeat this simple exercise until you can detect, in any landscape subject chosen for sketching, the five or six tones that form a basic pattern, or color range, in your sketch. You will, of course, be distracted by the local color of

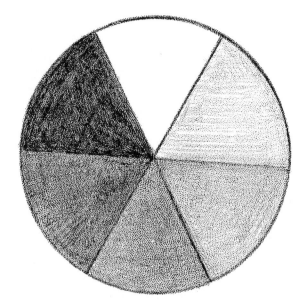

each object, by the green of tree foliage, the dark yellow or tan of a sand bank, the reflected blue of a pond. It is by comparison with other surrounding objects, comparison for *darkness* and *lightness,* that you learn to see accurately the tonal gradations.

Here is another game to play in the art of arranging the parts of your picture into a general pattern of tones that will be strong and interesting: Draw an oblong about the size of a postcard and divide it into five areas of different shape, with no two areas of equal size. Leave the largest area unshaded. Make the smallest area your darkest. Then shade each of the other three with a tone of gray, but make no two alike in value. Stand away from your finished design and note how much interest it has even though it is a surface pattern only. Turn it upside down, or on one side, and observe how the interest remains. Yet in such a pattern you have attempted to picture no rounded form. You have not consciously given it depth or third dimension. You may, however, get an illusion of distance.

The chief reason for this persistent study of values, or tones of shading between

black and white, is to train your eye for drawing *precisely* the graduated colors of a sketch, from your darker foreground, through the middle ground objects, to the farthest distance on your horizon. In the fancier vocabulary of art, this is the effect of aerial or atmospheric perspective. On clear, cool winter days distant hills may stand out, in some atmospheres, with a startling sharpness of color; but the artist working in black and white must produce an *illusion* of distance by graduated light and shade.

V. THE FOUNDATION OF BETTER DRAWING

THE COMPLETE VIEW

SO FAR we have been considering a number of fundamental ideas and practices in the art of landscape sketching. I shall now disclose how these are so related that when examined in summary, the whole groundwork of this art may be plainly seen. At the very beginning of our discussion I made the point that there is no best way for anybody to produce a masterpiece of landscape drawing in a few easy lessons. Every stage of development can be full of pleasure, as you know, but individual students differ markedly in their experience and abilities. Therefore no final formula can be presented which will suddenly reveal a set of secrets for achieving perfect results. For each amateur who tries to improve his ability there will be problems which can be solved only by repeated practice of the exercises outlined in earlier

Strong compositions are not caught by chance. Frances Hulmes, using a
felt-tip pen, combined the flat planes of buildings with angular horizontal
roof lines and fence rails and verticals of posts and trees.

chapters, in the field and at home. For the benefit of those who find it useful, I shall now reduce to compact statements all the main difficulties we have considered and the several practices by which they may be overcome.

A landscape sketch that combines an interesting surface pattern of values, solidly modeled forms, *well placed,* and distance, or third dimension, is, generally speaking, a well composed, firmly constructed picture. It is not easily achieved after a few sketching expeditions, but certainly such drawing is worth your best and constant efforts. You are not likely to produce such a sketch by deliberate, cold designing beforehand, by going into the field with a "floor plan" of composition and finding natural features of scenery to fit into it. On the contrary, the happy combination of all three elements will depend mainly on your observance of certain fundamental practices.

FOUR FUNDAMENTAL PRACTICES

1) Choose a simple, interesting subject.

2) Reduce it, by eye, to a few main units, strongly composed, omitting all distracting detail.

3) Study the subject intensely to "translate" the natural colors of outdoor landscape into a few simple values, or tones.

4) Work all over the sketch, for uniform development, not finishing it part by part.

Let us consider these:

Choosing a subject. Experienced photographers take pictures that have *one* major object of interest. The same rule aids landscape sketchers. Walk through the park, or along the beach, or across meadows and hills, until you find something which rivets your interest—an old house, a mass of trees reflected in water, a sand bank fringed with shrubs, a fishing pier, a point of pine-covered rock on the shore of a lake, a curving road beside a stony slope, a footbridge across a stream bordered by fields— the list could run for a page or more. Then study this chosen object from several angles to see from which direction it looks most attractive. The location of the sun will guide you by forming shadows around the main object that give more interesting effects from one side than from another.

77

Reduce the subject to a few strongly composed units. From your chosen viewpoint, so focus your eyes on the main object, with the use of the finder, that all other conflicting or distracting elements are either shut out or subordinated, kept down in tone or in size.

Begin your sketch by knowing what part or feature should be played up most strongly! Know also what, in the real landscape seen through the finder, should be omitted. Discover this by making a simple experiment: On a separate piece of paper— a small pocket pad is best—draw a quick, small preliminary sketch, in which you indicate, in note-making fashion, what should go into your large sketch. This note

A small rough sketch may reveal all main features.

may be smaller than a postcard, yet it should show plainly where the emphasis should come in the composition. It should show the main divisions of your picture space. It should show the best placing of main and subordinate features—hills, trees, reflections, the roof of a shack, a telephone pole. Most important of all, this "quickie" should show the best position for your horizon—how much sky should be in the picture. Make one or two "quickies" before starting any sketch.

Your large sketch will not always be an exact copy in composition of your best quickie. You may find, as your real sketch develops, that certain parts of the landscape

78

The small note serves as guide in developing the large sketch in stages. A field, darkened in the preliminary rough, is finally left unshaded, for contrast.

originally left out should be included; or that something included in the quickie may become a distracting element in enlarged form and should be left out.

You are not making an exact record of a particular place. You may therefore take whatever liberties seem necessary to produce a strong, well-composed sketch. This means using judgment about moving a tree closer to center, or leaving out rocks or shrubbery in one corner which, if put in, may unbalance your composition. You will find it desirable often to *exaggerate* the slope of a hill, or the height of a hill or tree, the curve of the tree trunk, or the angle of a fence, and so add interest to your design.

The reasons for "taking liberties" with landscape as it exists in nature are not always understood by beginners. Perhaps those reasons become plainer if we consider that the pleasure we now get from a drawing by Rembrandt, for instance, does not spring from any exact "truth" which the artist put into it on the spot, but from the planned effect of the design.

The drawing on the left was made from a reproduction of Eugene Boudin's painting, "Trouville Harbor." The other drawing shows one of several possible variations. A picture may record the character of a place, yet not be faithful in details.

Distances and the form of each feature in a sketch may depend on variations in the gray tones of light and shade.

Translate the natural landscape colors into a few values. The chief reasons for precision in putting in the tones of dark and light gray are (1) to show distinctly the relative distances of foreground, middle ground, and horizon, or farthest visible point; and (2) to show by light and shade the *forms* of your subject—the massive roundness of trees, the substantial, blocklike construction of buildings, the animated fluidity of water, the billowy fluffiness of clouds.

Foreground weeds and bushes in sunlight may appear in nature as brilliant yellow green; the foliage of trees in middle distance is green, but darker and less yellow; a range of wooded hills nearly a mile away may be bluish green. When you work with black pencil you must indicate these differences by using tones of gray with extreme care. Compare tones of foreground shadows with those farther away. Note the darkness of the shaded side of foliage and tree trunks in relation to ground shadows. Observe the grayness of blue-green hills, or a distant mass of trees, in relation to nearer trees, and to the sky *at the horizon*.

81

A handful of absorbent cotton about the size of an orange, if held near a lighted lamp, may appear as having, roughly, a ball-like form. The foliage of trees seen from some distance has a similar irregular roundness, the forked trunk running up through the foliage like a core, or framework. Light comes through open places in the uneven "ball" of foliage. But trees sketched in a field will appear flat in your drawing unless you succeed in showing precisely, in gray tones, the *gradations* of shade from sunlit to dark side. The top of the foliage will be bright if the sun is high.

The bulk of a hill must be shown plainly by a similar accurate gradation of tones in gray. These values must be skillfully detected among the greens, browns, and yellows of the grasses and shrubs that cover the hill. If the rounded side of a hill in your drawing is broken into hundreds of little patches of light and dark gray, the effect will not be roundness. Your problem always will be to simplify the mottled,

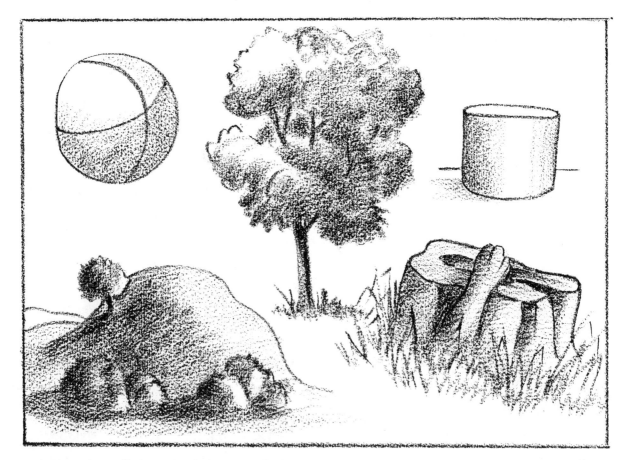

Drawn trees will have depth if the gradation from light to dark is observed and put down. The bulk of a hill or the cylindrical shape of a tree stump requires precision in shading.

spotty surface of a form, to show the *whole shape* of the form itself. It is accomplished by seeing, first, how the light from the sky reveals the main shape. If you allow your eye to be distracted by a hundred patches of color, you will not perceive clearly the few tones, ranging from dark to light, which indicate a broad, rounded surface such as a hillside or the hull of a ship. Practice shading a form in no more than three or four tints of gray, using the side of the pencil. Attempts to be oversubtle in shading

The error here is in the attempt to finish one feature of a sketch before the general design of the whole composition has been developed.

the stump of a tree, for example, will usually produce something flattened and form-less instead of the solid cylindrical body which a tree trunk is.

Work all over a sketch. It is a strong temptation among beginners in outdoor sketching to shade and "polish" first the one feature of a drawing which seems most interesting, apart from the whole composition. This is strictly to be avoided. At any stage in the development of your sketch you should be able to put down the pad, step away, and see clearly the *complete* design in process.

While you work, constantly look at the drawing as an unfinished but fully conceived design in which every part bears a close relation to the entire picture. It is a relation of tones, of light and shade. It is a relation of forms, of shape and size and

83

balance. It is a relation of near to far, in the third dimension, or distance. Therefore let your hand move from one area to another, indicating a distant rounded form, a foreground shadow, and a darker value near the center, perhaps to offset some shading of cloud or tree in a corner. Try to be sensitive to the gradual, steady growth of the composition—an increasing "definition" of your related design. By such uniform development the whole sketch should grow under your pencil as your eyes return, again and again, to take in the section of actual landscape before you which you have selected as the basis of your picture.

Train yourself strictly to draw in such a way that you are constantly alert to changing light and shade and to other relationships in the natural scene. Repeatedly compare sizes, distances, shapes, and tones of color in one part of the landscape with those in another. It is this habit which, in time, will make you master of any kind of subject you undertake to sketch. You will then know the freedom by which an artist can deliberately mold his drawing so that he is not limited by swift accidents of light, wind, or shadow, but is at liberty to make precisely the drawing he originally conceived when he chose for a subject the particular arrangement of trees, ground, water, and sky. It means the freedom to darken or lighten a hill, to simplify a tree by lopping off a limb, to omit an ugly fenceline, or to ruffle the reflection in a cove to add interest.

WORK FOR A HARMONIOUS EFFECT

This pleasurable feeling of handling the materials of a scene so that you can reduce them to your created composition cannot be achieved if you become distracted by the *details* of any single feature, however beautiful they appear. Once you have allowed the shadows on the side of a barn, for example, to pull your eye away from the uniformity of the whole sketch, in which the barn is but one part, then the picture suffers. You may produce in the barn door a little masterpiece of realistic drawing and subtle shading, but unless all other parts of the sketch are developed to the same stage of polished perfection, the door will forever stick out in that sketch like crudely applied lipstick on a pretty girl's mouth.

This principle of uniformity in the process of drawing can be observed without neglecting *emphasis*—the means by which you mark out clearly the main feature of a

84

The most effective practice is to work all over a picture after the main lines and principal shadows have been marked out.

landscape subject. In studying the drawings, etchings, or woodcuts of masters, notice how the subordinate parts of a picture, in the distance, or near the edges, have been less firmly defined than the main object—the boat, figure, or building, for instance—on which interest should be centered. This is a fundamental rule of good composition—that the eye of the beholder should not be pulled here and there, the attention scattered, but must be directed to the area of chief interest. The problem always is to accomplish this without weakening the whole general design. Close examination of dozens of drawings and prints by various masters will reveal how they achieved emphasis. As it is a product of experience, do not become discouraged easily if you find your skill wanting at first, when you attempt to develop to the right strength the principal features of a sketch, while retaining a strong pictorial design. Practice will bring marked improvement in that respect. All the study you can give to composition—as other artists have mastered it—will aid you directly to produce sketches that are well designed. Certainly you will learn soon that nature itself, as you find it arranged on a beach, or a farm, or elsewhere afield, rarely presents you with a perfectly composed picture.

Much of your artistry goes to solving this primary problem of *selection, omission, and emphasis.* Raw materials for a thousand sketches lie waiting for the talent trained to know those three processes—three keys that open one door to perfection.

MAKE THE MOST OF AN HOUR

One of the truly fascinating features of all landscape sketching, in any medium, is the satisfaction you may get even from brief periods of practice. I have cited the high value of making little preliminary sketches, notes, or quickies, to test your composition in miniature before you develop it in full size. This is a time-saving device as well as a good habit. Once you have hit upon a satisfying composition in note form, you can proceed at once to the real pleasure of laying it out carefully, enlarged, on your regular sketching paper. For an ordinary finished black-and-white sketch in pencil or crayon, one hour of drawing should be sufficient. Nearly a third of that time may well be spent in devising the composition, by trial and error, and putting in the main lines and masses precisely. I don't mean that every object in the sketch must be

In the upper sketch lack of contrast between foreground and distance, and between house and trees, makes for weakness. Emphasis, by focusing the eye on the main subject, strengthens the entire design.

drawn in twenty minutes. The parts of your sketch should, however, be finally located on the paper in that time.

It is more satisfying to make a dozen roughs, strikingly composed, than to spend the same length of time on one poorly constructed, yet labored sketch, in which several features—such as a tree stump, a fence and reflections in water—are shaded

Priceless experience may be gained by making rapid sketches of a number of different subjects, rather than wasting time and effort on the details of one inferior drawing.

in detail and with excessive pains. In the next part of this book you will find advice on practice in drawing many common natural objects found in landscape; but that sort of detail drawing demands less skill than many suppose.

Devote an entire week-end, or part of a vacation, to roaming about some attractive stretch of countryside or seashore with a sketch pad, and making a score or more of fifteen-minute compositions. You may discover many subjects within a relatively small area. You can return there on other days, of course, to do more careful sketches of some of the best of those subjects, after you have tested them first in rapid composition studies. Leslie, the biographer of Constable, writes of visiting that artist's

home neighborhood with a friend and identifying the scenery shown in eight or ten of the painter's most important pictures. The subjects were all found within a few hundred yards! What is of more interest, the discovery was made that Constable had not given exact views of the place but had combined and varied the materials, in some instances increasing the width of the river to improve his composition.

VARIETY, THE SPICE OF ART

As you will improve in landscape sketching only by repeatedly trying to solve a number of the most common elementary problems, vary your choice of subject. On one

A full week end may be well spent in doing fifteen-minute roughs in one seaside or rural neighborhood.

trip select part of a broad stretch of fairly flat country which offers features of interest in massed trees, for example, or a barn or some other simple form. On the next trip afield try a group of trees on the bank of a pond or river. On another, you may be able to drive to an ocean beach, or the beach of a large bay or lake, and choose a strip

unencumbered with buildings other than a plain boathouse or a wharf. After you have made a large number of full compositions, devote many an hour out of doors to drawing *detailed* studies of an uprooted tree, or a sand bank lying partly in shadow, or a footbridge over a stream, or a city waterfront shack, or a barge.

The advantages of deliberately seeking out such variety are obvious. One type

Vary the kinds of subjects chosen for your sketches.
Even such a study in detail as this may be simplified.

of subject will give practice in getting distance. Another will give useful exercise in close observation, for the drawing of detail. A third will offer a challenge in the difficulty of deciding what to omit. In this last case it is always satisfying to make two or more drawings of the same subject, in each of which different features are omitted. The comparison will be priceless in opening your eyes to the possibilities in simplifying for art's sake.

90

Each type of outdoor subject offers new opportunities to train observation, skill in composition, or taste in selection.

Make two or three drawings of the same subject on different trips, and experiment in omitting features.

SKETCHING FROM MEMORY

After you have been sketching out of doors for a few months, test your improved sense of observation in other ways. Chinese masters of landscape painting were rigidly schooled in the art of recalling an entire scene in all its essential features, and recording it from vivid impressions only. They absorbed the subject during hours, or even days, of contemplation. Modern Americans who sketch for fun have neither the time nor the inclination to cultivate such a philosophic approach to landscape. Nevertheless, sketching from memory is highly recommended and very rewarding.

One cold winter afternoon I drove ten miles to another town to see an art exhibition. On the homeward trip I rode across a broad valley and climbed a ridge. It was just after sunset, and as I looked back across the valley below I saw at the horizon an enormous blue-gray snow cloud shaped somewhat like the prow of a ship. Beneath were roofs of houses in rows and masses of treetops in clumps. The unclouded portion of the sky glowed with a strange blend of pink and bluish green. An hour later, when I arrived home, I sat down and painted a small sketch of the scene in water colors. I have always considered it among my best efforts in the medium.

Courtesy of the Metropolitan Museum of Art.

Detail from a painting by Ch'ên Shun. Chinese painters were skilled in working from memory.

The primary advantage of the method, for either drawing or painting, is that it frees the artist from the confusion of detail. The picture that is carried home in your memory will usually consist only of the main features of the landscape, impressed on the mind by intense observation. The countless little shadows and lights, lines and spots of detail, evaporate on the mind's mirror. It is therefore an effective exercise to stand a full ten minutes, or longer, before a chosen view, and then at home an hour or two later draw and shade it without resort to any sketched notes.

For your first few attempts it will be easier to work quite from impulse rather than deliberately to go in search of a landscape to memorize. From a car or train, or while waiting on a street for some tardy friend, you will unexpectedly see a subject that will impress you at once as perfect for sketching. Note keenly the relation of one feature to another—the building or row of trees standing against the horizon; the broad main shadows cast upon the ground or walls. Compare dark and gray tones, and the size and shape of the area they cover. Determine what central feature deserves emphasis. Remember where the horizon is. Keep the whole picture in mind for several hours, if possible, before you set to work on the drawing. The result will show you why many Chinese painters preferred that method exclusively. The poet Tu Fu once wrote, "It takes ten days to paint a rock, and five days to paint a stream." He was referring to the time needed to form a sharp picture in the artist's mind. The effort always was to depict the true character or atmosphere of a subject. It is more difficult, but far more artistic, than making a dull, faithful record on the spot of all the details of a place, and thus losing the real essence of the scene.

The snapshot may represent a scene as you saw it; the drawing, a sketch from memory in which ground shadow, trees, and pole formed the main features of the design carried in the mind's eye.

Photo by Patricia McNierney.

Pen drawing by an Italian artist of the sixteenth century. In modern drawings such a subject is
treated more broadly, but the effect of depth here is worth noting.

VI. TREES, WATER, CLOUDS, HOUSES, AND FIGURES

DOWN TO EARTH

TREES grow in city parks and in back yards, and upper limbs may be drawn from windows. If you are so fortunate as to live in a suburb, or in a rural community, "models" for practice in drawing trees will crowd upon you. City dwellers may have only a park to work in, or must wait for a season when week-end drives or bus trips will bring them to where they can see trees in a suitable light and at proper distances for drawing.

Many instructors of landscape sketching believe that the chief problem is to draw trees so that their family types can be recognized at a glance. This seems to smack less of art than of nature study, which is an admirable hobby in itself. By such reasoning you could as well begin the study of the human figure by trying to draw all the various racial types. What is most useful for the inexperienced is to learn well the fundamental anatomy and "geometry" of trees in general. Let the specific study of oaks, elms, maples, pines, sycamores, and poplars follow naturally with practice. Architects should know something of shrubbery by kinds, for they often use it as part of their design for the façade of a building or monument, and must be able to draw the type of shrub most appropriate for a certain style of house or most suitable to a locality. A landscape sketcher, however, must approach trees as living structural forms and as objects that often are essential in providing lines, masses, and tones in the composition of a sketch. He is not obliged, by any law of the painters' union, to put in every blooming tree that happens to grow in the scene he is sketching.

Seek first for an upright *stump* of a large tree that has been cut down. Begin by drawing that as a solid column in form, ignoring the bark and all surface lights and shadows. Consider the weight, bulk, and shape of the stump—a heavy cylindrical body rooted firmly in the earth; rising perhaps at an angle; its top a roughly circular section, seen in perspective as an ellipse.

That is quite enough to handle perfectly in your early attempts. A stump is one

of the easiest subjects in all landscape; it is not disturbed by wind as clouds are, or by dazzling surface reflection as water is. Draw many stumps. At first use the side of your pencil for rough shading, and later try to draw a bare outline so sensitively as to indicate the roundness of the trunk, and its thickness and weight, without benefit of shading. An uprooted stump lying on its side is an excellent subject for a simple drawing.

The best time to practice drawing entire trees is, of course, in early spring or late fall, when most types of deciduous (leaf-shedding) trees are all trunk and bare limbs and branches. Choose as your first model a tree that stands alone in a field or by the shore of a pond or stream. Draw it from a sufficient distance, far enough away so that when you study it, with your finder at arm's length, all of the tree can be included.

Observe by closer examination how the trunk divides, the approximate height

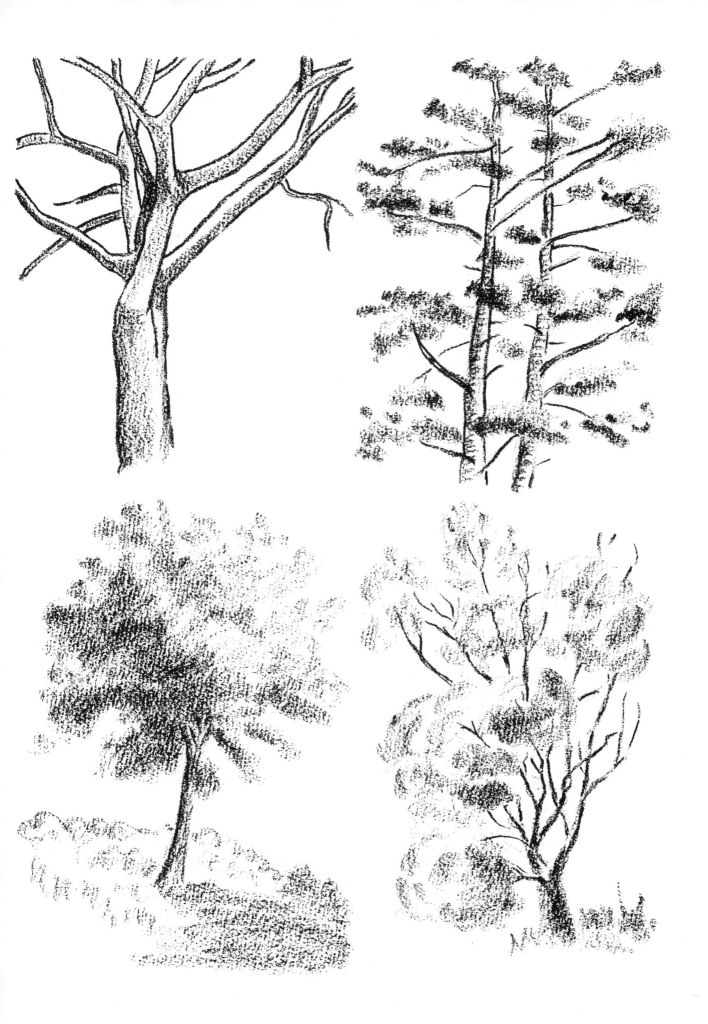

of the main limbs from the ground, and the angle at which smaller branches rise, or hang, from the main limbs. Above all, do not be confused by the maze of thin twigs against the sky. Squint at them until they appear as they may well be drawn, lightly, with the side of the pencil, as curved, hazy patterns, not as many little zigzag lines.

THIRD DIMENSION IN FOLIAGE

If a parachute were to be dropped over a bare maple tree or an oak, in most instances the general effect would be somewhat like a lopsided balloon with projecting knobs. I use the example to help you remember that imaginary circles can be drawn around the upper parts of almost any leafless trees. These lines indicate that many limbs project *toward* the sketcher, that the tree is not flat and fan-shaped. Foreshortening of

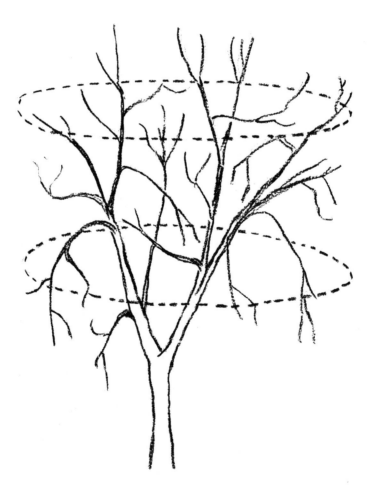

these limbs is a tricky problem in perspective. As your principal use for trees is likely
to be as masses of foliage, it is important that they be drawn to show plainly their depth
from front to back as well as from side to side. In part this is accomplished by observ-
ing their lighting, how the light from the sky, or direct from sun rays, and reflected
light from the grass below, strike the curved masses of leaves.

101

Begin your drawing of a tree by sketching the trunk and three or four main limbs, putting them in lightly, to get the skeleton for the foliage. See the firm, growing shape of the entire tree beneath the shadows and leaves. Note with particular care the relative thickness of the trunk and the off-shooting limbs. They have related proportions, just as the legs of a girl, however slim, will for most of their length be naturally heavier than her arms.

Before shading any section of the foliage in detail, block *all* of it out, roughly but lightly, to give you the entire shape of the upper part of the tree. In putting in the first dark shadows of the foliage, this general shape becomes further defined. Open spaces should be left unshaded to give lightness, airiness, and contrast to the heavier masses. This lets some sky be visible through foliage. But do not break up the foliage into a thousand little clumps of leaves. Each of the limbs will probably have a large mass of leaves around it for most of its length. Try always to avoid flatness and patchiness. Shade broadly, in curved strokes, not in niggling zigzags.

Two details of branches need special attention. Learn from firsthand observation how a small branch joins a main limb or the trunk. A slight swelling is often formed

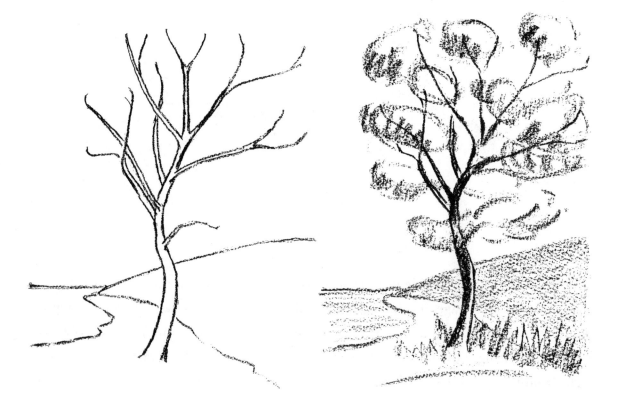

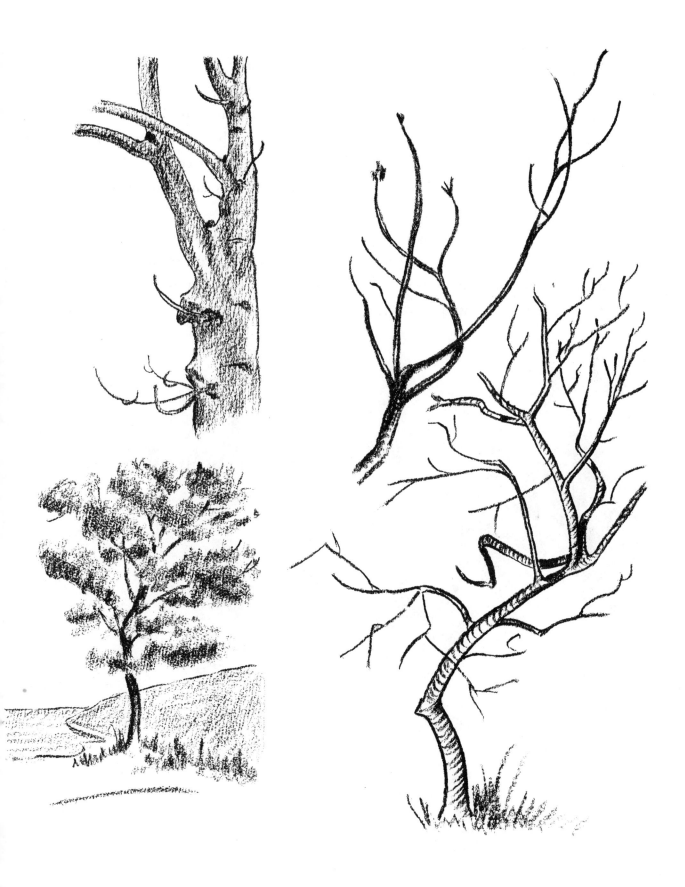

beneath the joint. Secondly, study and draw constantly, at every opportunity, the precise angles and curves of branches, some of the most beautiful lines in nature. Observe the character of each curve, just as you studied curves in sketching drapery. Consider the natural reason for the angle or curve of a branch—the rise toward a source of light or the pull of gravity. Deformed, injured, or broken trees offer no more than variations. Learn well the natural, common formations, and distorted specimens will be easily drawn.

Attempts to draw, without practice, a large tree in full foliage may discourage some students. I advise again that simplified drawings of a few *small,* bare trees be tried first, as "anatomy" lessons. In copying a photograph or drawing of a tree, endeavor to reduce the subject to a few essential lines, otherwise the exercise is useless.

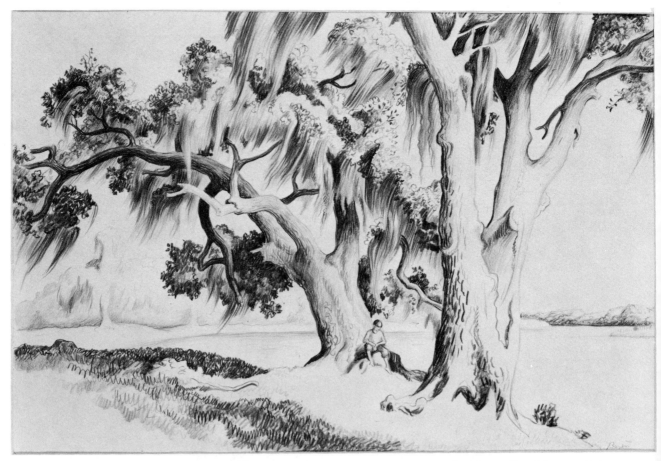

Courtesy of the Metropolitan Museum of Art.
"Live Oaks," by Thomas Benton, a pencil drawing on cardboard.

FOREGROUND FLORA

You should have little trouble drawing bushes, grass in clumps, or small shrubs. Try to catch their lively, upswinging curves Always suggest much more than you draw; the details are never so important in a foreground bush as the general shape and design which show the character of the plant—not its botanical type, necessarily, but whether it grows in tall, luxuriant, massed clumps of stalks and leaves, or hangs in thin sprays. Observe how grass is joined to soil, how thickly or sparsely the weeds grow on a bank of sand or sod, for that is how best to learn the true lines of growing forms. Usually they can be put down quickly and rather roughly, once you have learned to draw landscape with smooth, free strokes. Do not crowd a foreground with

Courtesy of the Metropolitan Museum of Art.

A detailed study of trees, in pen and brown ink, attributed to Titian. Observe especially the artist's determined effort to produce the effect of solidity and roundness in the trunks; also, the lively lines of the whole composition, achieved by the angles of the small trees and limbs. By accentuating such angles, Benton, in the picture opposite, produced an effect of movement.

small shrubbery or clumps of grass. Occasionally put in a row or band of grass, drawn sketchily, to aid your composition. But leave plenty of open space in foregrounds, suggesting rather than drawing grassy patches of ground. A sand bank or dune topped by fringes of wind-blown grass is a subject worthy of your effort at any stage. Do it,

however, with an economy of line, broadly, freely, and without superfluous detail. It is art, not botany, that you must consider.

WATER IN MANY MOODS AND LIGHTS

The surface of a pond or a slowly flowing river on a bright, windless day is likely to be a dazzling, brilliant pattern of color. The blue sky will predominate, but over-

lying it in the reflections will be brown and green from trees and shore line bushes. Even a slight breeze will streak the water clear across in horizontal silver bars. It is a subject that lends itself to experiments in technique. Water color or oil paints are, obviously, superior for the purpose to any black-and-white medium, such as lead

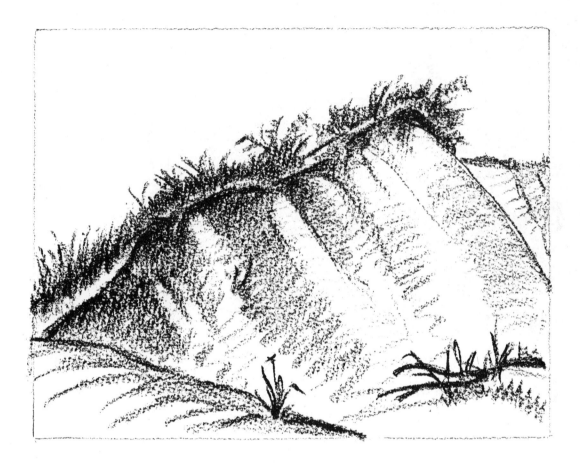

pencil. Yet you should learn to draw water well in shaded tones of gray and white before you attempt to paint it. Later, when you begin to use a colored pencil—terra cotta, for example—as well as a black pencil, you will be more successful in catching on paper the variety of lights and shadows of a lake, bay or stream. Kuo Hsi wrote, "Water is a living thing: hence its aspect may be deep and serene, gentle and smooth; it may be vast and ocean-like, winding and circling. It may be oily and shining, may spout like a fountain, shooting and splashing; it may come from a place rich in springs and may flow far; . . . it may be charming in the company of mist and clouds, or gleam radiantly. . . ."

Comparison of a still body of water with a mirror is a literary flourish rather than an accurate pictorial figure. The unruffled surface of a pond is more like a sheet of plate glass than like a mirror. Near the shore some of the brown mud and dead leaves at the bottom may affect the surface color. Across this neutral tone may lie dark and light bars, streaks and reflections of light, vertical and horizontal. The easiest way to simplify the realistic appearance of water is to draw the dark reflections straight down, in broad swaths of gray or in zigzag lines, and then, with an *eraser,* draw a few light streaks across the *surface* of the water. On brown or gray paper a stick of ordinary white chalk may serve a similar purpose, but the marks are usually too light unless rubbed carefully with a finger. It requires skill to draw any water, so your attempts will improve with practice under a variety of conditions.

Observe that along a lake shore or a river bank there is usually a thin dividing line of light between the sod and grass at the edge, and the reflections of trees growing

108

near the water. Distinguish with care between shadows on the surface of water, such as those caused by a cloud, and reflections in water.

As in drawing foliage, so in shading water, *avoid overdoing* the complexity of the pattern. A few carefully placed vertical dark bands of reflection, and one or two horizontal bands or streaks of light, where the paper is left or erased clear, are sufficient.

In sharp, rather than blurred, reflections the angles of trees and the vertical lines of buildings on shore must be drawn with extreme precision. Often you may be astonished when, because of distance, light refraction, and a ruffled water surface, you can see little or no reflection of trees or buildings standing along the opposite shore of a river. Yet the upper part of a high hill some distance beyond the water may make a dark patch of reflection in midstream. A knowledge of simple perspective, plus accurate observation of light effects, should enable you, with experience, to record authentically with a pencil almost any kind of water surface. Do not attempt difficult stunts, such as drawing rolling surf or the rapids of a mountain stream, until you have succeeded in doing well the simpler reflections in still water.

COMPOSING: WATER OR SKY?

The next related problem to solve is whether the area of water in the subject of your sketch is important enough in interest—for form and values—to make it the largest area in the picture. This may mean that your horizon would be high, leaving little or no space for sky. There is nothing wrong with that kind of composition if the water is worth all the space you give to it. The upper part of such a picture may be filled with a row of trees and a suggestion of clouds. But always, when there is bright water in a sketch, you must decide (1) where it should be placed in the composition, and (2) how much space it should occupy. I have drawn many pictures in which the shore of a river was used as a strong diagonal line, running from a lower corner straight across the picture into the distance. In such compositions the water surface may take up a full third or more of the total space, and the sky almost another third. But unless the water has real interest, because of reflections or movement, it can be a dull, blank stretch in the picture.

Water may take large space in a sketch if it has interesting patterns.

CLOUDS ARE NOT COTTON

The sky in any sketch may make or break the composition. Water surfaces rarely lack some source of interest, for they support boats and they reflect light and shadow. A sky may be blue, gray, or pink, or combine several tints, but these are hardly the concern of one sketching in black crayon on white paper. Clouds are pleasing forms in three dimensions, and they often cast shadows on the land below. They are necessary in many sketches to add darkness or lightness to the upper part of the composition.

An artist must constantly study clouds as they appear during various kinds of weather conditions. Camera studies of clouds, of a kind usually found in magazines issued for amateur photographers, can be useful for copying. Real clouds may move and change shape so rapidly that few beginners in outdoor work can hope to catch their forms accurately. Consider them here not for themselves but as aids to good composition, as adding interest and color to wide areas of sky that otherwise would deaden your sketch.

112

Although clouds are not formed of anything like cotton, they do deserve a treatment that will show their vast dimensions. If you draw a procession of several white, fluffy clouds across a summer sky, the underside of each will be in shade if the sun is high. A winter sky, however, may consist of bold streaks of dark blue and pale gray, in jagged or uneven pointed bars.

I have sketched on a Cape Cod beach on days when the surf and sand seemed uninteresting in comparison with the mountainous masses of cloud along the far horizon of the ocean. One morning, after a week of fog, the weather changed suddenly and the wind blew the fog out to sea as it lifted. The effect was weird and dramatic. It required water color to catch on paper the vast, low blanket of dark lavender and gray clouds rolling along overhead, flowing swiftly seaward. The surf was lighted by sun, the spray was blowing diamonds, and at the far horizon, where ocean and sky met, was a broad band of blue. But the dark clouds made that sketch.

Ordinarily, however, nothing elaborate need be sought or invented in cloud formations to break up a stretch of dullish sky. It is possible to suggest, by a few

lightly shaded curved bands, that the sky in your sketch is not cloudless. Do not put in overhead clouds as though they were painted on a heavenly curtain hanging at the horizon. Often the clouds are suspended far overhead, like the billowy hangings covering some celestial ceiling. Study the perspective of such forms, and let your lines sweep freely from the horizon at an angle that will indicate how the clouds continue above you, beyond the limits of your picture. Shade them so that the most distant undersurface of cloud is kept well back near the horizon.

HILLS FROM ABOVE AND BELOW

In one season of outdoor sketching you should be able to master elementary perspective as applied to landscape; to develop a sensitive hand and eye for the roundness and solidity of hills and tree trunks and for the subtle gradations of tone in foliage, water, and clouds. But these commonest features of landscape will not provide all your

114

problems. As soon as you begin to draw with ease and freedom such fairly simple subjects as I have discussed in detail in these pages, you should be ready to attempt some new experiments.

Sit at the base of a hill that is climbed by a road or a path, and topped by an interesting barn, an old house, or a clump of trees. Try to work out a composition that will show at once the steep, rising hillside and its roundness. Your horizon will be placed high—in fact, you can turn your sketching paper endwise, to get more effectively the impression of height.

The narrow strip of sky at top may be broken with a few wisps of cloud. If the hilltop that makes the horizon has a curve, accentuate it. Find something at the bottom of the hill, near you, which can mark the foreground. Next, curve the road upward, first deciding exactly where, at the bottom, this road should *enter* the picture. The center of the bottom line is usually an awkward place; one side or a lower corner is preferable. Fence posts, telegraph poles, or a line of trees and their shadows may aid in showing the steep rise in the hill, marking clearly the direction of the ground. Then

sketch in roughly the mass of trees or building at the top, noting correctly the angles of gable roofs seen from below. When you have the composition completely laid out, and before you finish the shading, put down the sketch and step away, to see if you have plainly drawn the structure of the hill. Your first efforts may exasperate you, but this little problem is worth all the patient work you put into solving it. The satisfaction in achieving the right effect is reward enough. Thereafter you can tackle stiffer problems with more assurance.

Climb the hill and draw it in reverse, showing how the road drops away steeply before you and descends to the valley, perhaps in a wide curve. The foreshortening of the foreground is, as you readily will see, the most troublesome feature of such a sketch. Your landscape below, with a few roofs and a tree or two seen almost in bird's-eye perspective, should offer less difficulty than the first hundred feet of road near you.

The curve of the edges, as the road begins to drop steeply downhill, must be caught precisely or the road will not descend at the right angle. The sky will probably occupy the major space in this picture and help support the illusion of height. Unless this division of your space is carefully marked at the outset, no amount of shading or shifting of lines later will help achieve the effect of height you must strive for.

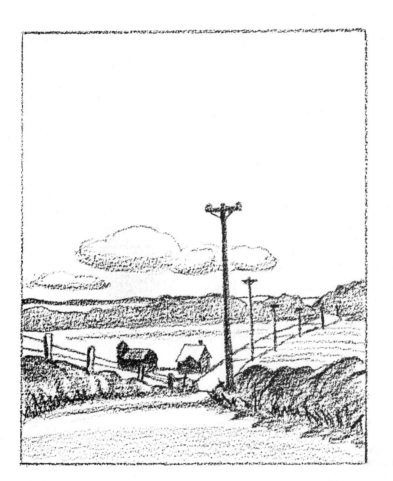

When this challenging subject has been tackled and mastered, you may be ready to take on something similar but a bit harder: the drawing of a street or roadway, with houses, from your roof or from a high window. Everything is more acutely fore-shortened. The position of the horizon is very important. Simplify the detail in the street by choosing to sketch only one or two simple low buildings, and perhaps some trees, a car, and several roofs. Attempt the subject as an exercise, to give yourself a

new pleasure and the assurance that your weeks of practice in outdoor sketching have really equipped you to control lines and forms seen from any angle.

SHADOWS FOR COLOR AND CONTRAST

I am using the term "color" now only in the sense of various tones of gray, from white to black. Constantly, in all your trips outdoors, you will be compelled to observe, as a primary feature of landscape, the way light colors and shapes the forms of houses, trees, rocks, clouds, and other objects. I have discussed the effects of daylight on such forms. This is so fundamental in the whole process of learning to see and to draw out of doors that nearly everything else in sketching may seem of secondary importance. But the roundness of a rock, for instance, is perceived not only by noting how one side of it receives light and the other does not, but also by seeing the roundness in the curve of a *shadow* of grass or foliage that lies across the surface of the rock. The roughness of

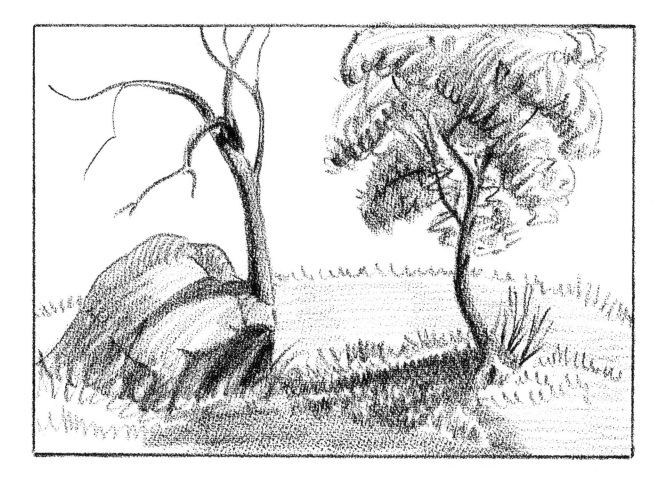

a plowed field or an uncut park lawn may be seen in the way a tree's shadow lies upon the uneven ground. I am now considering not "shading" as we see it on the surface of a tennis ball under a lamp, but the shadow cast on a table by the ball or on the ground by trees or buildings.

Usually the tone of a shadow lying across grass will be lighter in value than the darkest shadow on an upright tree trunk. Reflected light from the sky and from surrounding surfaces, as well as the yellow-green color of grass itself, may dilute the ground shadow of a tree. In contrast, the darkest side of the tree trunk will be in almost unrelieved shade; it may get some indirect light cast up by the ground.

Observe with the utmost care, therefore, all shadows cast *on the ground* by houses, trees, walls, or other upright objects. The stripes and other patterns of tree shadows lying across a country road in late afternoon or early morning offer a subject for study. The secret of drawing shadows well is always to *compare* their dark tones

119

with something darker, and then try to keep the shadows transparent rather than fill them in with solid black. Shadows are never really black out of doors.

THOSE BOTHERSOME CHIMNEYS, ROOFS, AND WINDOWS

In Chapter IV I urged you to make rough sketches of barns, sheds, outbuildings, cabins, park shacks, and other simple structures. The exercises there suggested—the drawing of an open book set up like a tent, and of a shoe box seen from various angles— were intended only as elementary aids to getting the knack of drawing in true perspective the roofs and walls of any tall, squarish building, with or without a gable roof. But you will not be satisfied with drawing from a distance such simple shacks and barns as you include in your sketches to add interest to the composition. On many occasions you will be tempted to make an old house or other building the main subject, and draw it carefully, with attention to certain architectural details that should be accurately drawn. Making dozens of small sketches of windows, doorways, and roofs should help train your eye to recognize types of construction. You can learn something from copying such details of buildings from clear photographs in magazines. An amateur artist may have no reason to be technical about such matters, but even a sketchy drawing of a farm building or an old country house will require more than hasty observation of how the roof is sloped; where, and how, the chimneys rise from it; how the windows and doorways, porches and steps, are designed.

Farm buildings in themselves are a fascinating study, ranging as they do from chicken sheds to huge barns flanked by the tower of a silo. Old Pennsylvania barns have odd gable designs and overhangs, sometimes supported by stone pillars. Those of Delaware may have thatched roofs, and in Virginia the oldest barn or shed walls may be of logs. A few New Jersey types are illustrated here, and one fairly modern and spacious structure done in New Milford, Connecticut. But there is individuality about barns, and you will find pleasure in the problem of catching the character of each one you draw. It is not the petty details and oddities that matter so much as the *general design* of the structure, and that's usually determined by its age.

Shingled beach cabins are fairly simple and best done in profile or three-quarter view, so that their location atop sand dunes, or up above the surf, or back from a road,

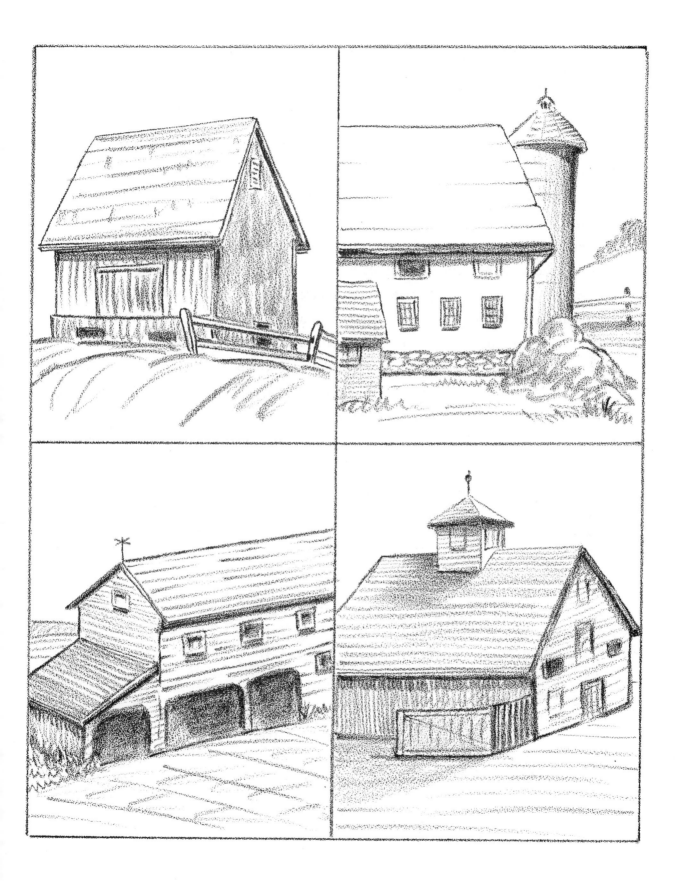

may be clearly shown. They usually have small screened porches, the deep shadows of which require care in drawing; keep such shadows transparent, for there is always much reflected light at the seashore and little or no shade from large trees or tall buildings. The lakeside cabin or vacation cottage of clapboard or shingles is more difficult, for often it is set among trees and is mostly in shade.

Observe especially that the various materials used in the construction of a farm shed, or the roof of a beach cabin, or the painted walls of a silo, affect light and shade falling upon them. Weathered tar paper or similar roofing used on sheds will be much lighter and reflect more sun than will old brown shingles. The actual color of the paint on the wood or stone exterior walls of old houses affects the tone of the shadow or light on the wall surface. Notice the difference between the color of sunlight falling on a yellow clapboard house wall and that on a dull red barn built of wide boards.

Make several detailed studies of the roofs, chimneys, and porches of old houses. In some styles the overhang of the eaves of the roof will be very wide. The eaves of a gable may be supported by large wooden brackets or eave moldings, and their spacing should be measured in detailed drawings. Pay particular attention to the construction of the edge of a roof. It is not a single, straight, thin line, like the edge of a sheet of cardboard, but consists of rafters, supporting moldings, and often several *layers* of timber and roofing material, such as shingles.

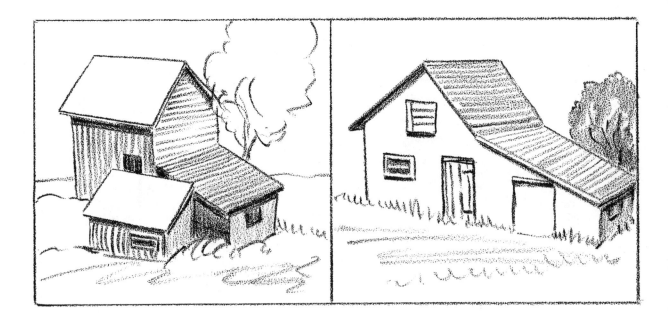

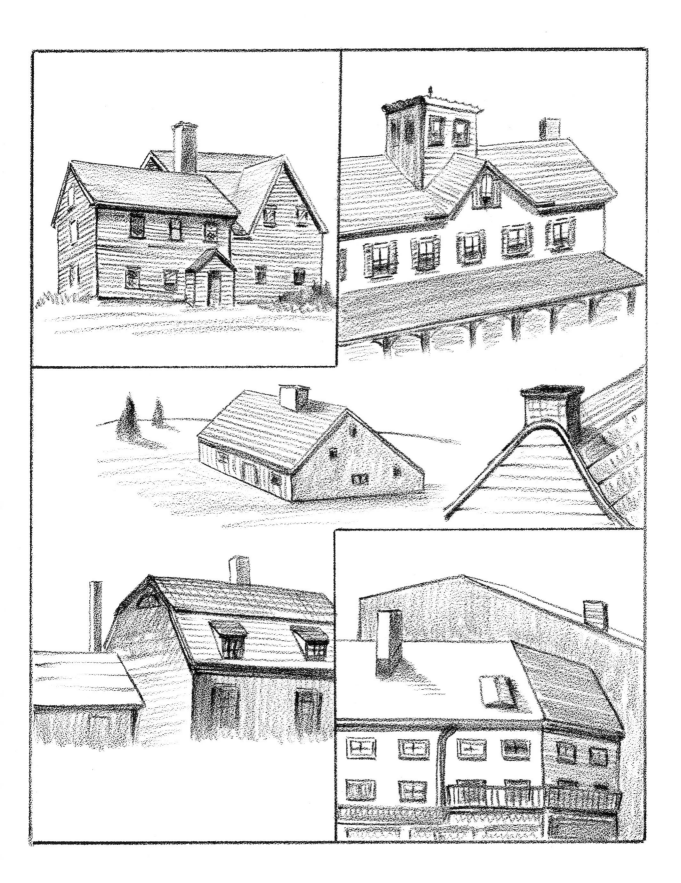

The shadows beneath eaves may be very dark and wide. When the sun is in certain positions, the shadow will be a broad band extending well down the wall of the house. It is important to put it in correctly, not for architectural accuracy but for the contrast in lighting which affects the design of a form in your sketch. I mention all these seemingly trivial matters that come to notice in the sketching of a house or other structure because it is necessary to learn to *see* all buildings with an artist's eye, just as it is necessary to see landscape, which for the most part goes unobserved because we are so familiar with the general aspects of it. When you begin to sketch houses, you will discover all sorts of odd facts about them which heretofore you never had any reason to know.

Study all types of chimneys so that you can draw them with ease. They seem deceptively simple, but require care. Their number, width, and height are usually related to the size of the building, or help to characterize its age or style. On a beach bungalow there is usually one low chimney, projecting only slightly above the ridge pole. On a few old Cape Cod houses the tall collared chimneys seem ludicrously out of proportion, but are part of that quaint style. The Dutch homes on Long Island and in northern New Jersey, built of red sandstone and with upper stories of clapboards, often have chimneys that straddle the very ends of the gable roof. The chimney material—red brick or yellowed cement facing—is of interest because of the effect on transparent shadows.

Porch railings look difficult but are fairly simple to indicate by suggesting the supporting bars, drawing them in groups, sketching only a few, just as bricks are drawn in a building wall. Something behind a railing—porch furniture or the outside wall of the house—may modify the shading on the railing itself because of what can be seen through the bars.

Crudely drawn doorways and windows may go unnoticed in *rough* sketches of old houses, but this is no excuse for careless drawing of perspective in more finished work. Window frames and doors are a study in themselves. They deserve close observation if you would make the houses in your sketches look genuine in all essential details. The proportions of windows—the width in relation to depth—are of fundamental importance. If, as a result of hasty observation, you draw low, squat frames in a style of house commonly fitted with tall, narrow windows, the error will be apparent even to the ordinary observer with a superficial knowledge of house design.

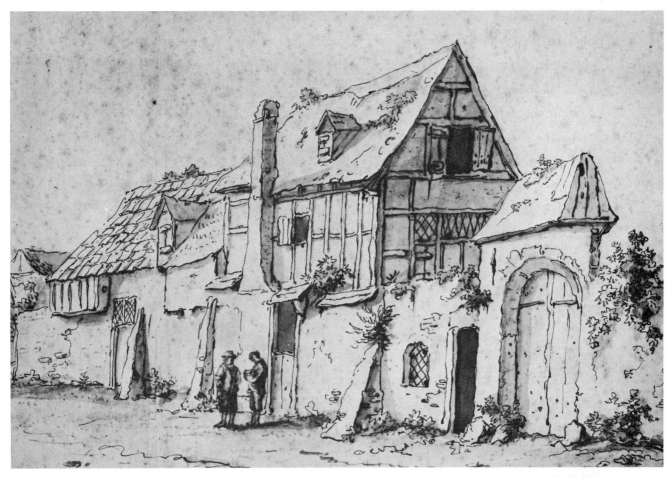

Adriaen van Ostade, who made this drawing in seventeenth-century Holland, defined plainly the "character" of the house, and, despite detail, left broad areas open. Note how harmonious is the style, no one feature protruding for attention.

Except in houses that have grown by additions through several generations, there is usually some *unity of style* which makes certain standard shapes of windows and doors appropriate to houses that have a particular shape of roof and facade.

The small attic windows under the eaves at the ends of old houses are frequently semicircular. They call for care in drawing to get them in proper perspective, else they will stick out from the surface of the wall. Church windows rounded at the top offer a similar problem. Basically it is the common difficulty of drawing an ellipse from the correct angle. Draw the window frame as an *oblong* in the proper perspective, and work out the ellipse within that for the round top.

One easy way to practice drawing architectural details is to sketch parts of the

house next door, or near your home, as it can be seen through one of your own windows. Work patiently to get every angle and every shadow precisely right, and every vertical line true. Give special care to the *comparative* widths of window frames, eaves, clapboards, and shutters. With your eye, measure one against another. Avoid drawing shutters so narrow that a pair of them would not cover the window they flank. The slope of a roof must be drawn precisely at the right angle. The space between windows should be so carefully measured, even in a sketch, that the last window in a row is not squeezed for lack of room. One house drawn in detail, repeatedly and with care, will teach you more of sketching buildings than will hasty drawing of dozens of different houses chosen as subjects solely for their quaintness.

FIGURES TO PEOPLE YOUR LANDSCAPES

Pictures of wooded hills, farms, old houses, or rocky beaches can be so interesting for natural features that human figures are usually unnecessary. But one or two well-placed figures, or even a group of several, often will add interest. If you intend to do sketching in and around a city, you will find frequent use for skill in drawing simple rough figures. If you decide later to paint or draw pictures in which figures will be the most important feature, you may develop ability for that purpose by practicing with the aid of such books as Andrew Loomis's *Fun with a Pencil, Figure Drawing for All It's Worth,* and *Creative Illustration.* I propose here only to indicate some of the principal ways in which landscape artists have used figures effectively in drawings, etchings, and paintings.

In sketches of city streets and parks the main features generally are buildings—old churches, rows of old brick houses, skyscrapers, bridges, waterfront scenes. But an authentic sense of life and atmosphere should mark such compositions, hence the suggestion to include a few walking or standing figures. Even when they are sketchy, they help to show in scale the height of buildings. Often they are drawn as an irregular row of dark upright "spots" across a foreground. They cannot be distinguished as individuals, but represent moving crowds or groups of pedestrians crossing at corners or striding along the sidewalks. Joseph Pennell, who did a remarkable series of drawings of London about thirty years ago, nearly always sketched figures in this way,

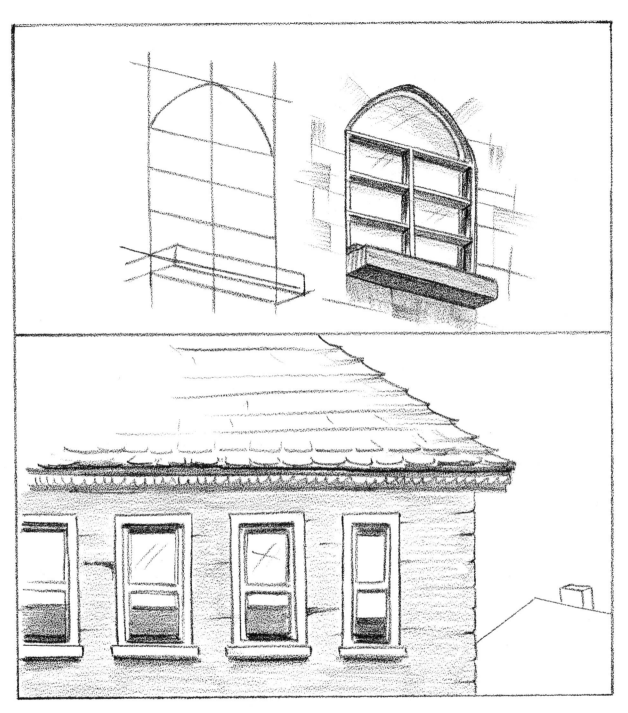

The arched window drawn from an angle can best be handled within an oblong in perspective. The width of windows and shutters should be approximately right, to avoid the effect of squeezing the last in a row, for example.

as suggestive spots at the base of tall buildings, across his foregrounds, in interesting groups. They gave movement and authenticity to his striking views of the city. It is not even necessary to draw complete figures to give interest to a sketch; part of them may be cut off by low walls, cars, or other objects. When drawn against *dark* doorways or in the deep shadows under bridges, they can be made as small light spots for contrast.

Another more dramatic use is to place one or two figures in a broad rural landscape, so that they seem dwarfed by the hills, the massed trees, the curving beach and

Rough composition from a drawing by Joseph Pennell.

water. George Inness, the nineteenth-century American landscape artist, painted perfect examples of this. Many modern artists—John Steuart Curry, Paul Sample, John Costigan, and others—use small figures effectively in landscape pictures. The placing is, however, of great importance. As the figure is subordinated in the landscape, it is usually best put into the middle distance, off to one side, but nearly always distinctly darker or lighter than its surroundings.

In seashore sketches the absence of tall trees or imposing buildings that cast deep shadows may raise problems which a few simple figures can help solve. Groups of

128

Sketch made from George Inness's painting, "Windy Day."

The composition of Eugene Boudin's "Beach Scene."

figures drawn from some distance and shown seated or standing on a beach, provide the kind of central *vertical* feature that gives life and color contrast to the drab, flat, horizontal character of many seaside compositions. Such figures are usually well placed to right or left of center, of course, and back beyond the foreground. But, as in most other advice here on composition, there should be no iron-bound formulas!

Finally, there are countless landscape subjects in which one figure, or a group of two or three figures, is just as important as any other feature of the design. Such, for example, is the Winslow Homer composition discussed in detail in Chapter III.

From *The China Magazine.*

Clever use of figures in Yeh Chien-yu's painting of a Chungking street and a water-bucket line.

Homer usually gave figures much significance and they are essential parts of his compositions. As fishermen, hunters, or brown natives of tropic isles, they are more than merely appropriate to his landscape subjects—they are integral parts of each design and seem always part of the landscape. Paul Gauguin's work provides even more striking examples of the same principle.

You may sketch a street scene in which only two figures are shown, but those prominently placed and easily distinguished as strollers, shoppers, businessmen, or street vendors. They are therefore "characters" in your scene as well as parts of a composition, and must be clothed with the correct costumes even though sketchily drawn.

Sketch rough figures from life at the beach or on a casual walk through your

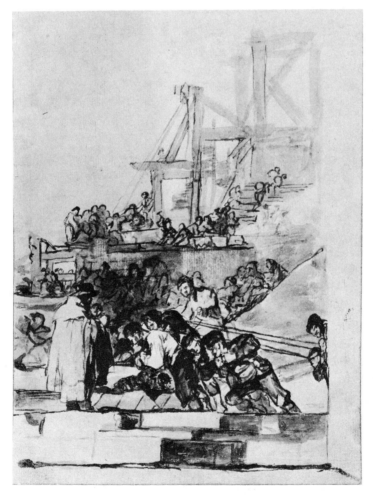

Courtesy of the Metropolitan Museum of Art.
Drawing in sepia wash by Francisco Goya, showing figures
in action in construction scene.

city's park on a Sunday afternoon, and save those sketches. You can later put a seated or standing figure into your landscape by drawing from memory, and in that way avoid dependence on the chance of finding subjects for figures when and where you need them. Consider them as an effective means of adding interest, and as nearly always essential to street scenes. If you are working on a large sketch for possible exhibition and wish to experiment in the placing of figures, draw them roughly on scraps of paper, cut them out, and move them around on your sketch until you find the right spot. If they are not a main feature, they should not be so placed as to distract from that feature, or throw your design off balance. But this little problem, like so many others I have mentioned, adds variety and fun to the art of sketching.

VII. SKETCHING UNDER DIFFICULTIES

THE KIT IN THE CAR

IF YOU can go sketching by automobile you may save much time that can be better spent than in traveling afoot or by bus or train. This does not mean that you can eliminate footwork entirely. As you drive along a country road you will see many a likely subject and be deceived into thinking that you can stop anywhere, walk into a field, and begin to draw. Then you may discover that what looked good from your seat at the wheel of a car has a less interesting aspect when you sit on a rock or on your folding seat placed on the ground. The whole composition changes when you lower your viewpoint two or three feet. In many places you may find it feasible to sit sidewise in your car, with the door open and your feet out, supported by the folding seat or a soap box. This usually enables you to work in sufficient light. At all times, obviously, a car can bring you to places where landscape subjects abound, and you can then roam at will on foot until you find something that stops you with its possibilities for composition.

By sitting beside a car, you can often work in the shade. The constant glare of reflected sunlight from a sketch pad may all but blind you to the subtleties of natural color which must be translated into shades of dark and light gray. It is nearly always well to choose a subject that can be studied and drawn from a shady location. The

foliage of trees will cast mottled shadows upon your sketch paper and add to other ordinary difficulties of seeing the subject and your sketch. The shade cast by your own head and shoulders may be sufficient in most places to cover your pad. I have often painted sketches against the sun, to get certain light effects in water colors or oils, by sitting with my back almost turned toward the subject and working between repeated glances over my shoulder to avoid looking long at the sun.

SCOTCH MIST

Artists vary in temperament and in their preference for seasonal and weather conditions. Whistler, Pennell, and countless lesser workers in landscape did remarkably good work on days of mist and rain—or at least they were able to carry back to the studio impressions and quick sketches made in fog or drizzle, pictures which could be used to construct paintings of scenes having a high humidity.

When I tried to sketch in water color in Edinburgh, Scotland, in the spring of 1935, I found that frequent showers cramped my style. The dampness prevented the paints from mixing well on the paper. Yet the Scots have many talented water colorists. They have been able to adapt their materials to some maddening weather conditions, drying their sketches with a spirit lamp at various stages before completion. Many an American who goes in for landscape sketching as a hobby prefers to sit at home on drizzling days and emulate the Scots only in refreshments.

SUNLIGHT AND SEASONS

I have always enjoyed most the pleasure of sketching on sunny mornings or late afternoons from mid-April through November. But that preference, of course, comes not so much from choice as from the necessity of making the pursuit of my hobby fit the particular place on the map where I live. My occupation keeps me in a city office five days a week and provides a month of vacation in summer. Every season presents its own special kind of beauty in landscape. It is easy in a dry climate to sketch outside even on cold winter days. For sketching in color—in pastels, crayons, or water colors—

Early morning or late afternoon—the hours to be determined by the latitude—offer chances to outdoor sketchers to use ground shadows for striking effects. This is especially important in drawings in black, in which sunlight cannot be shown as painters can show it, by color.

late afternoons in spring, summer, and autumn usually present the most fascinating shadows, light effects, and skies. In the middle of a sunny day, on the contrary, shadows are short and the landscape too well soaked in light, too glaringly brilliant, for those contrasts in value that make for abiding interest in a composition.

135

The fundamental principle for each amateur to follow is to take full advantage of (1) all spare daylight time from his work; (2) seasonal changes; and (3) geographic location.

On your home neighborhood's location will depend, in part, how much variety of landscape subjects you have access to. But all trips to new and strange places will

Absent-minded artists sometimes run shadows in two directions in the same sketch, usually on days when lack of sunlight makes shadows indistinct.

open up that variety and add to experience in sketching. Be determined that you will not develop fussy habits, such quirks as being unable to sketch unless it is a spring morning or a misty fall afternoon. You have chosen a year-around hobby. Your fair-weather sketches can be used to advantage on stormy days in your home studio, though that be only a table in the corner of your bedroom. When snowdrifts blow against the

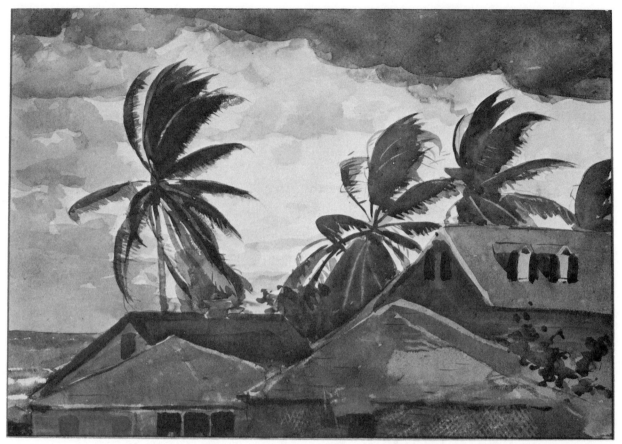

Even this black-and-white reproduction of Winslow Homer's water color, "Tornado, Bahamas," conveys the artist's direct impression of a storm. The use of simple means to get the effect of motion shows mastery of composition.

house, you can sit indoors contentedly recomposing a scene you sketched in the spring. But more on that later.

Sketch out of doors whenever you can, at various hours, so long as you use a medium suited to the conditions of light and atmosphere on each day's trip afield. Your black pencil cannot be a magic wand that will draw autumn foliage in grays which will convey all the charm of natural colors. With experience you will know what subjects require one or more colored pencils in combination with your black. The next section of this book goes further into that tantalizing problem. Unless you have had firsthand experience, you cannot imagine the pleasure to be found in trying to adapt one medium or another to the climatic conditions under which you work and to the kind of subject chosen. A wharf with a fishhouse overlooking a bay will call for one kind of paper and medium, while a barn beside a field of wheat may need

quite another combination. Each subject will have one aspect on a dull, cloudy morning, and quite another aspect on a bright afternoon.

WIND, GLARE, AND DULL SKIES

As you will find advantages in sketching in shady spots, so you may prefer to choose a place where, if possible, you do not face the glare of sun reflected from the surface of water or from a road and where you will not be working in strong wind. Blinding reflections of light, as I said a few minutes ago, temporarily weaken your visual ability to see the differences in tones of dark and light color values. For that reason sun glasses are sometimes useful for black-and-white sketching if the lenses are not too dark.

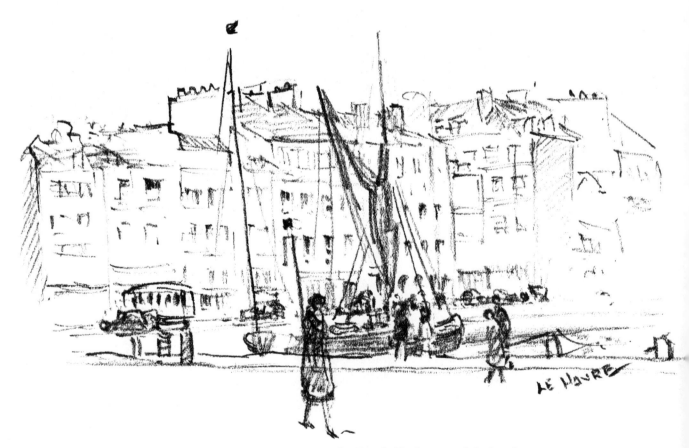

Waterfront in Le Havre, by Frank Herbst, a quick sketch.

Percé, Gaspé, Canada, by Michel G. Gilbert. The original is 13½ x 19 inches, and in light brown crayon pencil on rough-surface paper. Observe in particular the strength with which the main elements—the headland and the boat—are defined, the interesting foreground modeling, and the effective overhanging sky. The firmness and simplicity with which the artist put in his principal shadows is also well worth noting.

Dull, cloud-filled skies are likely to be less of a hindrance than at first you may suppose. In fact, some painters—George Bellows, for one—preferred overcast days because they could work free of the glare of sunshine and under conditions in which colors and forms could be observed unaffected by the accidents of changing shadows. The more experience in drawing you gather, the less dependence you will have on the modeling of landscape by bright sunlight; you will easily see good compositions on days of pale shadows. One of the most effective water-color sketches I have ever seen

was done almost entirely in grays; the subject was an old freighter riding at anchor in morning mist.

SWIFT WORK ON THE RIVER

Some of my most instructive experiences in adapting simple sketching mediums to uncommon conditions came on a trip on the Ohio and Tennessee Rivers. My wife and I traveled hundreds of miles on a stern-wheeler—a steamboat of modern construction but old-fashioned design, driven by a huge rear paddlewheel and surmounted by tall twin smokestacks. In that stretch of the Ohio which runs from Cincinnati to Paducah, Kentucky, are many river locks. As the boat, moving downstream, entered a lock, most of the passengers went forward to watch the process of descending to the next water level. I hurried to a little stern cabin, or to part of the deck where I could get unobstructed views of the opposite shore while the boat was not in motion. But it did have a slow *vertical* motion. As the water level in the lock was lowered, my horizon gradually rose. I therefore had to work very fast, using a water-color brush and following no pencil drawing, but painting a simple sketch directly from the slowly elevating scene in ten or fifteen minutes. It was swift work but fun, for the pictures, in all cases, were composed of a few strong lines and masses. Weeks later, when I returned home from that journey, I tried repainting several of these quick sketches and even made crayon drawings from one or two just to learn whether, by working more slowly, I could improve on the original. I did not always succeed, for the original had a strength born of clear, rapid observation and swift, sure execution—swift it had to be, because the boat was seldom tied up for longer than twenty minutes. The spontaneous qualities in the best sketches could not be fully recaptured in copies. I learned a great deal on that trip about omitting needless and cluttering detail in landscape.

COWS AND OTHER FAUNA

The fields, pastures, and seashore, for all their beauties in the best weather and at the most enjoyable seasons, are sources of minor discomforts which now and then tax the

This drawing was made at home from a water color 12 x 16 inches done rapidly from the deck of an Ohio River steamboat. The boat was tied up for a brief stop.

patience of the most enthusiastic amateur artists. By experimenting with a variety of bug killers and odorous deterrents to insect life, you may find your own favorite way to keep flies and hornets from hindering the production of pure art. Pipe smokers may have an advantage, and in recent years science has come to our rescue with new lotions and other chemical aids. But while I have forgotten innumerable attacks by blood-thirsty mosquitoes, I still remember vividly the day on which a fine sketch was accomplished in spite of a deliberate invasion of my artistic privacy by a herd of cows. I had, to be sure, first invaded their field by climbing a wire fence and setting up folding seat and sketching equipment while they were nibbling lunch a quarter of a mile away. I was so absorbed in work on the picture that I did not discover, until surrounded, that as they cropped grass they had slowly moved in to block my view. The nearest cow had such an angry glare in her eye that I backed against the fence. The cow tilted over the seat with her nose, and I finished the sketch well outside the wire, squatting on a dry rock in a stream. At that moment a herd of rhinos could not have seemed more formidable. Milk-fed city artists may take fair warning.

VIII. DABBLE AND LIKE IT

EXPERIMENT WITH SIMPLE MEDIUMS

COMMERCIAL artists and illustrators, in general practice, choose their tools and other working materials with one purpose in mind: the end justifies any means. The end, in their case, is a picture which will be perfectly suited for reproduction in a magazine or newspaper and which will have precisely the effect desired by the art director or advertising agency that buys the work. But amateurs who sketch landscape for pleasure alone are free to play with all sorts of pencils and papers. They are bound by no typographic, mechanical, or commercial limitations. That is why you will not get the maximum enjoyment from your sketching as a hobby until you discover, by countless experiments, how to achieve a variety of effects. In the course of these experiments you will no doubt make numerous mistakes. You will turn out pictures that will sorely disappoint you. But in the end your reward will come in experience and more self-assurance.

You have nothing to lose by trying every available kind of drawing material and painting material to produce outdoor sketches. Even when the results are poor no time will have been wasted, for you will have learned more about your own abilities, limitations, and difficulties in handling several mediums. It has been said that differences in their sense of humor divides nations, that individual differences in temperament enter into the reason that one girl or boy does well at the piano, and another takes to the violin or a brass instrument. Similarly you may discover, regardless of your sex, age, or background, that you can handle water colors or pastels better than oil paints, or turn out better sketches with a lead pencil than you can with colored crayons. But never be convinced or prejudiced for or against any medium until you have given it a fair trial. The fairness consists not only in a trial over a sufficient period of time, but also in the use of high-grade materials rather than cheap substitutes. I refer not only to paints and crayons, but also to papers.

As my purpose has been to simplify the entire process of landscape sketching, all advice and instruction has been offered with the understanding that you would first master the primary practices of this art and use to that end nothing more complex than

a few pencils and pads of white drawing paper. You could go on practicing endlessly with no more than that and learn a great deal of sound, basic stuff about the art of constructing landscape sketches. Add talent to practice, and you could conceivably do pictures as genuinely artistic as any drawings done out of doors by Homer, Bellows, or Sheeler, and never vary your few working tools. But as in any other art followed for pleasure, or any sport, variety adds zest, and it helps progress. I propose to explain now some of the many ways in which you should try to vary your materials to suit certain conditions and purposes.

PENCILS FOR MANY PURPOSES

In your early practice it is well to use a black pencil with a fairly soft, thick graphite lead. This will tend to aid all efforts to draw broadly and with increasing freedom. Working with sharp-pointed pencils at first, on the contrary, develops the bad habit of drawing very small pictures with an excess of details in thin lines. You should strive to understand the construction of *masses* within a composition rather than put sketches together with lines that stay on the surface, like patterns on a rug. As you gain experience, your sketches should be made with freely swinging wrist and elbow motions, not with tight, cramped finger motions. Work often with the *side* of the pencil point. For variety of line effects, try the broad, flat lead pencils now made for sketching. They are suitable for many kinds of landscape work.

A harder and sharper pencil—No. 3 or No. 3H—will occasionally be useful for laying in lightly the first lines of a sketch that requires some drawing of detail. Such lines will be easy to erase or can be worked over with a darker, softer pencil. As you practice on different paper surfaces and with various types of pencils, you will discover the best combinations for your own style. You will learn to control a soft pencil stroke to keep it as light as necessary for shading; for example, the foliage of distant trees.

Black crayon pencils—paper-wrapped pencils—or a high grade of school crayon in black, are useful, especially for a broad style of sketch in which there are few foreground details. In such sketches the desired effect may depend on getting precise values

The left half of this sketch is in soft graphite pencil, the right half in lithograph crayon. The picture was done only to show the difference in the effects. For ordinary purposes these mediums do not combine well

in a few large areas rather than on getting all the finer variations in many small shaded areas.

Black chalk pencils are easy to work with, and they give pleasing effects on many papers, for their line is a dull, not a shiny, black—and not a silvery gray. I usually prefer them to ordinary graphite pencils for most work, but they should be of the best

145

Thoreau's Cove, Walden Pond, Concord, Mass. Drawn on the spot, on the centennial of Henry David Thoreau's moving into his cabin.

grades and brands or they may be gritty and crumbly. Charcoal pencils, if well made, are easier and cleaner to handle than ordinary charcoal sticks, but both smudge. A fixative spray, obtainable in art supply shops, will help preserve charcoal drawings.

In fact, pencils are so inexpensive that it is well to buy, of any kind, the best brands made for artists. The quality of your drawing will depend much on the ease with which you control your medium and achieve the desired strength of line and shadow. Never go out into the field without several blunt and sharpened pencils, and carry some of several kinds—graphite, crayon, and chalk—after you have practiced with each of them.

INTRODUCING COLOR

For sketching in spring or autumn and in certain parts of the country where the predominating colors of landscape are browns, grays, and sepias rather than a variety of greens, you should experiment with certain colors that combine well with black. I have in mind terra cotta, sepia, or dark red, all of which can be had in crayon pencils and in pastels or other chalks. The so-called "sanguine" conte pencil, used alone or with black chalk pencil or black crayon, can produce very attractive sketches. The dark reds and light browns, or sepias, are invaluable for drawing autumn grasses and shrubbery, rocks, old farm buildings, and similar subjects requiring touches of color. In combination with black, they can be beautifully shaded and blended in strong, simple compositions. Try several sketches done entirely in terra cotta or sepia. The range of values will seem limited, but the effects obtainable are quite different from anything done in ordinary black lead pencil.

If you itch to try all shades of colored pencils, to go on a rainbow binge, suppress the impulse for a time, until you have learned to use a *few* colors with ease and in the right proportions. Experiment, for example, with a black, a sanguine or sepia pencil, a dark brown, and a dark green crayon or pencil. Use the black and, with restraint, the sepia for the sky, for light clouds, but use all four colors for middleground and foreground tones. Of course, red chalk or other chalks cannot be combined well with crayons of waxy material. Pastels and most other chalky substances of any color in pencil form will blend easily and can be applied over one another; combine your

147

colored pencils with that in mind. After you have practiced with black, green, and the reddish-brown shades, add a rich golden yellow. I have mentioned here only a very few of many combinations for your earliest attempts in the use of colored pencils.

Use the same restraint and simple color range in trying pastels out of doors. With the soft, round pastels you can get certain effects—sunlight on a hot day, for instance—not easily obtainable even with water colors. But I strongly advise against going out on a sketching trip with a large box of pastel crayons in fifty or sixty shades. Instead, begin with only seven or eight—black, Indian red, dark yellow, a dark and a light blue, a dark and a light green, and vermilion, all of good quality.

"Haitian Hut," by Violetta Glemser—pastel crayon on light tan paper. The foreground in the original was touched with green, the sky done in white and yellow.

In the original, the sky, distant mass of trees, barn, and foreground trees were done in black chalk pencil. The entire area of the hill and foreground were done in terra-cotta (sanguine) pencil, also the foliage on the left.

PAPERS FOR MANY USES

All the white paper you will use may be considered, for convenience, as having either a smooth surface or one with a surface of some degree of roughness. After you have been sketching for some weeks on the sheets of a plain white pad, 12 x 16, or 16 x 24—the larger size is preferable for full landscape work—you may begin to experiment with other kinds of paper. Pads of rough-grained white are usually sold in art supply shops and can be used for your first trials on that kind of surface. Blocks of paper, usually more expensive, size for size, are very handy for traveling, as they serve without the thumb tacks or rubber bands generally necessary to hold loose sheets on a board. But you may find it more practicable on many occasions to buy large single sheets of paper, about 23 x 30, and to cut those into convenient size, such as four 11 x 15 pieces. These can be fastened to a board of thin plywood or firm cardboard somewhat larger in size.

The high-grade rough-grained paper used for many water-color sketches is often too rough and hard for small pastel or crayon drawings. A less expensive machine-grained paper is easier to work on, among rough-surfaced papers, and may give a more satisfactory surface for your needs in outdoor sketching. But there are many types of smooth cameo papers, as well as bristol board of light weight, which can be bought in large sheets for cutting up and which are of excellent quality for *finished* sketches, after you have spent a sufficient period in drawing roughs and doing other exercises. Conserving your best grades of paper for larger and more finished work in sketching is suggested not for the sake of economy only. When you are traveling or away on vacation, for instance, you will probably be unable to buy good sketching paper; so bring along an adequate supply when you go on a trip and conserve the best or most useful papers for large sketches and complete subjects, doing your small rough sketches and detail studies on pads of fair grade.

Eventually, and with experience, you may easily be tempted to abandon almost entirely the use of white paper. I give my hearty approval to yielding to that temptation. There is nothing more satisfying than to sketch on a moderately grained buff, cream, or light gray paper surface. Black crayon always looks well on the darker shades of cream-tinted paper, and a rough surface adds interest, provided the subject does not call for close detail. In choosing a paper surface, use ordinary common sense

The upper drawing is on smooth, dull-finish white paper, and in the same black crayon pencil used on the rough white paper sketch shown below it. Choice of paper depends on the medium used and on the subject

in selecting paper that will suit the kind of landscape you are working in. Some types of subjects—city streets, buildings, boats, bridges, and similar objects requiring detail—are best done on *smooth* cream paper. Broader subjects—rocks, wooded hills and valleys, farm scenes, river banks—may be made more interesting on light brown or gray paper, with or without grain. Light shades of brown wrapping paper, if not of the shiny-surface type, are suitable.

Of course, if you are using one or two colors with black in pastels or crayons, your choice of color in paper must be made with a thought to the effect of such drawings as you may do in sepia or red chalk, or in green and brown. On gray paper the use of white chalk and a black conte crayon or similar pencil can be very effective. But use the white with care. It serves for highlights, for a roof reflecting sunlight or for reflections in water. It can be toned down with a light rub of your finger. Erasers help in drawing reflections in black and white chalk.

WORKING ON TINTS

Except for one purpose I am not discussing in this book the technique and methods of water-color sketching. That purpose is the tinting of paper on which you can sketch with pencils. On white sketching paper, 10 x 12 or larger, paint a very thin wash of pale sepia, pale green, or yellow, and let it dry thoroughly before using it in the field. The effects, though depending on a technical trick, are nevertheless pleasing when the sketch is drawn entirely in black or in some dark colored pencil such as brown.

A FEW ADDITIONAL SUPPLIES

With no more than ordinary ingenuity you should be able to make an outdoor drawing board of some sturdy yet lightweight material, wood or cardboard. Preferably it should not be smaller than 16 x 20, and could be larger with advantage. It should take large thumbtacks easily, for you may often work on the top one of several sheets of paper tacked to the board.

The use of sun glasses and eyeshades out of doors is entirely a matter of personal

An 8 x 10 inch piece of watercolor paper was covered with a smooth sepia wash, and when this was dry the landscape was drawn in black crayon pencil. Same technique is useful where lights such as water reflections can be put in with white or yellow chalk.

preference, and has been referred to elsewhere. On numerous occasions I have found both of them aids to comfort. You can often see bright reflections of sun on water more easily through sun glasses than without them, because such glare as the surface of water can reflect may be almost blinding. But if you have green or blue lenses in your glasses, the color effects may distort your values and make the use of colored pencils difficult or impossible.

Your sketching kit, light and simple as it may be, should include a few single-edge razor blades and a small sandpaper block for sharpening pencils, and perhaps a blade in a holder for cutting paper. I have also found useful leatherette or cloth zipper

cases, about the size of a long business envelope. For occasional quick sketching, these will hold a few pencils, kneaded eraser, sandpaper, thumbtacks, chalk, and other small supplies, and may easily be carried in a pocket. With even this compact kit you can, if you wish, make a sketch the size of a bedsheet!

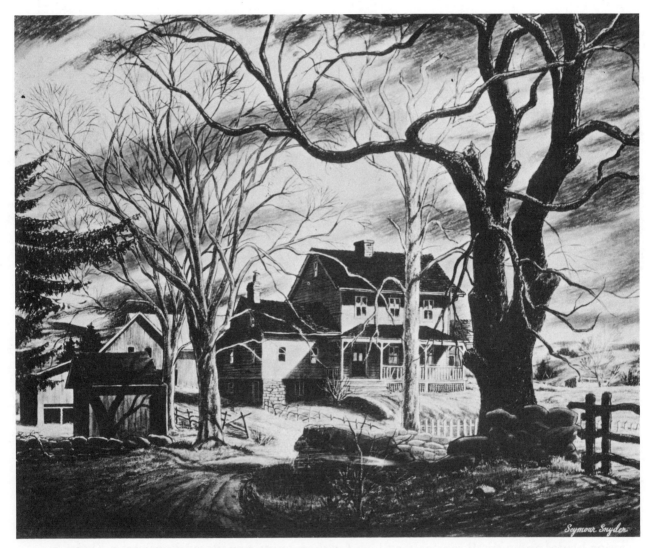

In this india ink brush drawing Seymour Snyder achieved strong contrast, balancing the large, dark mass of a foreground tree against lighter background area of the house.

IX. WHAT TO DO WITH YOUR SKETCHES

ENLARGE THEM FOR THE WALLS

WHEN you have succeeded by persistent, patient, and intelligent practice in making drawings worthy to decorate your living room, you will find extra pleasure as your reward. You will be able at last to share your satisfaction in this art with family and friends. You never need be ashamed of showing pride in displaying work produced after serious self-training and the application of experience. But you may also find yourself becoming so fond of original work done outdoors that you won't part with these sketches, however your friends may plead. You will then find pleasure, as well as a valuable lesson, in making copies, preferably larger than the original.

Your first discovery, when you attempt to copy at home on your drawing board a sketch made in forty minutes or so in the field, may be discouraging. You will find nearly all work and little joy in transferring such a picture to another sheet of paper, line for line. It will seem a slow, mechanical business. You will, I assume, make a freehand copy by setting up the original drawing before you on the table and marking on the paper used for the copy a few simple measurements, to get the composition fairly accurately. Your chief difficulty will be in your *mood,* which will differ considerably from that in which you made the original drawing. Then you were intent on the serious matter of selecting the right features of the landscape, omitting others, and emphasizing those parts of the picture which would bring out the strength of the general construction. You were then reducing to black and white a landscape in natural colors. You worked freely, swiftly, and at some moments almost by intuition. There is a certain subconscious element which enters into a good sketch from nature, as into a good piece of creative writing. You *feel* rather than think about certain lines and masses and the placing of them. But at home, faced with the task of directly copying a finished sketch, you may find yourself at a loss to retrace the stages by which your original was developed. The hardest problems were all solved in the field. Moreover,

you will work so slowly over a copy, have so much time to be distracted by details, that the dynamic quality of the original is likely to be lost in the process.

WAYS AND MEANS TO IMPROVE A SKETCH

It is usually best never to try to improve an original sketch after you bring it home. You may darken a part or use an eraser or chalk to brighten a light spot, merely because in the dimmer light of your house the design of a sketch may reveal a weak place or two. But when you *copy* your own sketches you can work without restriction, for you are then producing an entirely new picture which may be made different, if not better.

The first improvement may be enlargement. An original pencil sketch 9 x 12, for instance, could very well be copied to better effect in 12 x 16 or a larger size. You may find the extra inches in depth an advantage in giving more space for sky, and thereby add much to the composition by a slight change in proportion.

Three treatments of one subject: Done outdoors first in blue, green and yellow watercolor (lower right), then copied in black crayon, and again (on smooth paper) with pen and india ink.

A second improvement may be in technique. Try copying entirely in red chalk pencil or terra cotta a drawing done originally in black crayon or ordinary graphite pencil. The difference will astonish you. Whether the colored copy is superior may depend on whether the color is appropriate to the subject.

A third improvement is in the use of a different shade or surface of paper. I have already discussed the various advantages of smooth or rough white, gray, brown, or buff papers. A drawing done in black on smooth white could, for example, be copied on rough gray paper in black and sepia crayon pencil, with white chalk for highlights. Trying that kind of experiment is fun, not drudgery. The results are usually so different from the original that the copy becomes quite another creative effort. One simple sketch in pencil may thus be an inspiring original from which three or four different pictures may be produced, each having special qualities that justify the making of it.

But your true talent and training can best be exercised by copying in larger size, and with radical *changes,* a sketch that did not wholly please you when you finished it outdoors. The first major operation is to leave out in the copy some offending detail—

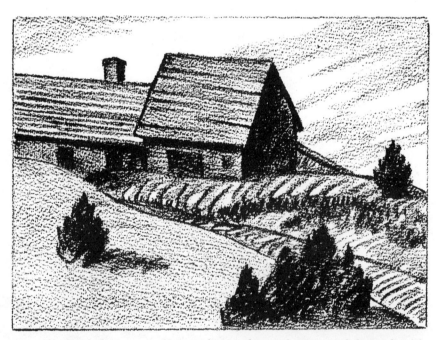

A small sketch in any medium, when redrawn larger, and framed with a wide mat and molding, becomes effective for exhibition. Enlargement may require changes in composition.

a tree, or a cloud, or a distant hill—which may have impaired the original by deflecting interest from the main subject. One problem of enlargement may be to retain interest in a foreground, for example, which seemed perfect in the smaller original. You may find it necessary to put into the copy an extra reflection in water, or a bush or rock on barren ground, to avoid a broad, vacant, and therefore uninteresting expanse of paper.

Landscape drawings are frequently sent to exhibitions in much larger sizes than those you are likely to make in the field. You can add to the size and interest of a copy by having it framed with a wide mat. The frame itself need not be much wider than half an inch or so, of black, gray, or plain unpainted wood. But a well-made mat of generous width will make a mediocre drawing appear more interesting than a small, unmatted, unframed masterpiece.

The evolution of any plain little pencil sketch, therefore, is almost without limit.

It may be enlarged to twice or three times its original size; drawn on paper of different surface; done in colored pencils; the composition improved by correction of an error; and the finished copy handsomely set off by a broad mat, new frame, and glass. To accomplish all this does not mean that you are guilty of practicing mechanical tricks to make poor work look better. You have only carried into further stages, and by the use of your own judgment, a sketch which was not only worth doing originally for itself, but which served as a means to other ends. In any group exhibition your sketches must face competition from the work of other artists who likewise will make the most of their own work by any legitimate means available.

NEW PICTURES FROM ROUGH SKETCHES

I have referred elsewhere to the priceless value of all original outdoor sketches, in pencil, crayon, or chalks, as raw material for paintings. All professional landscape artists have made such use of drawings done from nature. Save every successful sketch you make on field trips and translate some of them back into color with brush and water colors or oil paints. It is a severe test of both artist and sketch. In most cases it is preferable to return with your paints to the spot from which you made the pencil sketch and make another in color, under different lighting conditions, probably, but with fundamentally the same or better composition. There is no more effective way to make small landscape paintings than to paint them directly from nature—or from a quiet street corner early on a Sunday morning. When you have mastered composition and color values, however, you may be able to copy a pencil sketch in paints at home, enlarging it and using a limited palette of colors. Even if you paint in black wash an enlarged copy of a pencil sketch, you will have created quite another picture.

Innumerable artists have used landscape sketches as subjects for prints. If you save your crayon and pencil drawings of trees, houses, and landscape compositions, a day may come when you will be impelled to learn the technique of the wood block or the lithograph stone. Then you will have priceless copy material for experiments in the new medium. Actually, as you know, there is a closer relationship between the methods of pencil drawing and the arts of the lithograph or the wood block than there is between painting in oils and making woodcuts.

160

Lithograph by Violetta Glemser, notable for solid draftsmanship.

When you have been drawing out of doors for a period long enough to train you for truly effective work in sketching, you should have little trouble in copying some of your best sketches with a grease crayon on prepared limestone—under proper instruction, of course—for the production of lithograph prints. If you should attempt the cutting of wood blocks, you may transfer to that medium those of your sketches which are marked by simple composition, by sharp contrasts in light, by broadness of treatment, or by bulk and massiveness. Your detailed studies in pen or pencil of buildings, or street scenes in which architecture predominates, may eventually become suitable material for etchings or drypoints, should you be attracted to either of those fine mediums for the art of print making.

I am only disclosing briefly here, for the novice, some possibilities for using the kind of skill in landscape drawing which he may develop by constant effort in the simple mediums discussed elsewhere in this book. Just suppose, on the contrary, that you should take up first as a hobby the making of woodcuts before you tried outdoor sketching. You might soon master the technical processes of that medium, but you would be severely handicapped in executing a variety of subjects, for the medium is utterly useless unless it serves to transform designs or drawings into prints. Without firsthand experience in landscape sketching, you would be forced to trace onto your wood block landscape drawings made by others, and thereby would lose part of the profound pleasure which comes of creating something artistic from the first to the final step.

Still other uses to which you can put a stock of good landscape drawings may seem obvious, but should not on that account be neglected. The hobby of outdoor sketching may well become the foundation for a career in magazine illustration or design. If your daily occupation is such that it may lead ultimately to work in commercial art, none of your hours spent in the field with pad and pencils or pastels will have been wasted. The study of industrial and advertising design will reveal countless ways in which your drawings of streets or beaches, fields and streams, can be turned to the practical needs of composing illustrations, greeting cards, or designs on merchandise of leather, wood, or metal. All that you have learned in actual practice during weeks or months of intense pleasure in sketching trees, hills, water, barns, houses, and boats, will add enormously to your skill in composing any kind of design for any commercial or artistic purpose.

162

If your present intense interest in learning to draw outdoors with ease and artistry springs from nothing more than a frank pursuit of pleasure, you may enrich your life beyond the power of words to tell. Only he who has ridden this hobby hard, and thereby learned to sketch in masterly fashion, knows how treasured a possession is his trained talent. He may use it for no other purpose than to illustrate his vacation trips and holiday hikes, making of these a delightfully personal record which may be left to his children. Who will ever be able to measure, in any terms of material value, the contribution which this practice of a fine old art has made to the physical, mental, and emotional development of a personality? No man or woman for whom life has taken on deeper meaning as a result of intelligent effort to record in pictures, for the pleasure of it, some part of the world in which one lives, will willingly abandon such a hobby, whether the product of it be honest craftsmanship or fine art.

Woodcut by Letterio Calapai, designed for a book illustration from a pencil drawing by the same artist.

A FEW HELPFUL BOOKS

THE drawing of one landscape sketch outdoors is probably worth more than any thousand words on the art. When the novice has practiced and mastered the primary principles he can refresh his memory and encourage his talent by consulting the published advice of others and, by comparing methods, find those that suit his taste and style. Some of the following titles should be helpful:

The Artistic Anatomy of Trees, by Rex V. Cole (Dover) has more than 500 illustrations, and detailed instruction on the drawing and painting of trees.

Drawing in Chalk and Crayon, by Kay Marshall (Watson-Guptill) has much useful information on materials, techniques and elementary drawing principles.

Ernest W. Watson's Sketch Diary (Reinhold) provides a range of examples of landscapes and buildings in dry and wet media, with notes.

The Joy of Drawing, by Gerhard Gollwitzer (Sterling) includes helpful studies of the basic forms found in landscape.

Conte, by Cedric Dawes (Studio Publications) offers clear instruction in black and white conte-crayon sketching, landscape and figures.

Creative Lithography and How to Do It, by Grant Arnold (Dover) is an authoritative manual on methods of transferring drawings to stone and other surfaces for printing.

The Art Spirit, by Robert Henri (Lippincott) provides much inspiring and practical advice by the noted painter who was also a great teacher.

A Portfolio
of Master Drawings

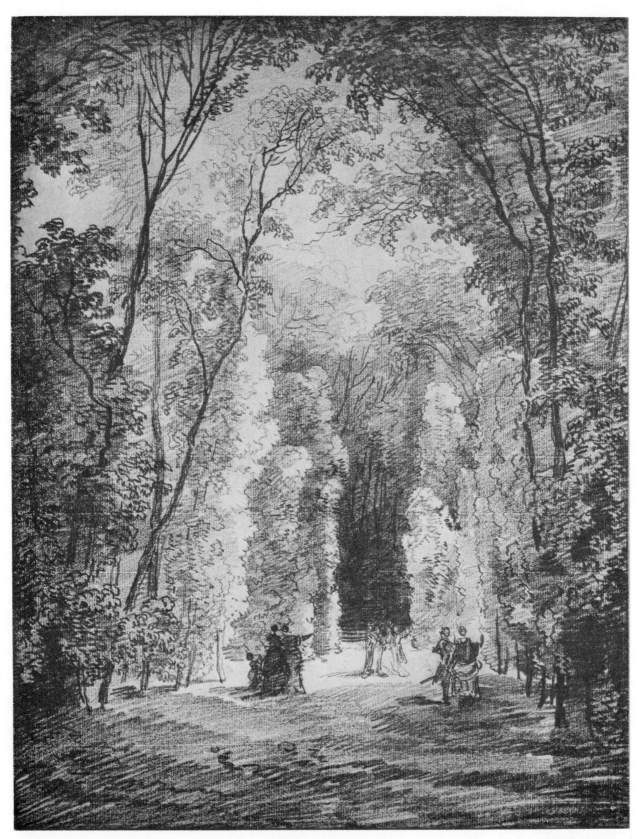

PLATE 1. "The Avenue" by H. Robert. Red chalk. The contrast in lighting adds power to an otherwise weak subject.

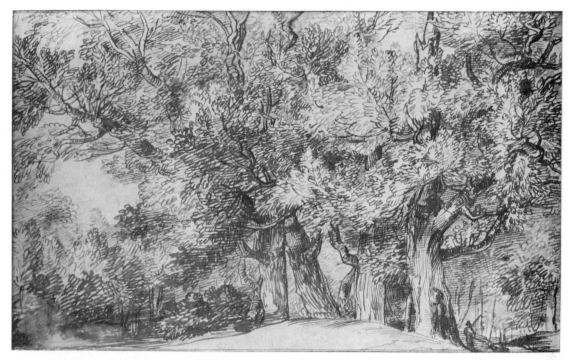

PLATE 2. "Wooded Landscape" by J. Lievens. Pen and bistre. An instructive
example of solid forms well combined.

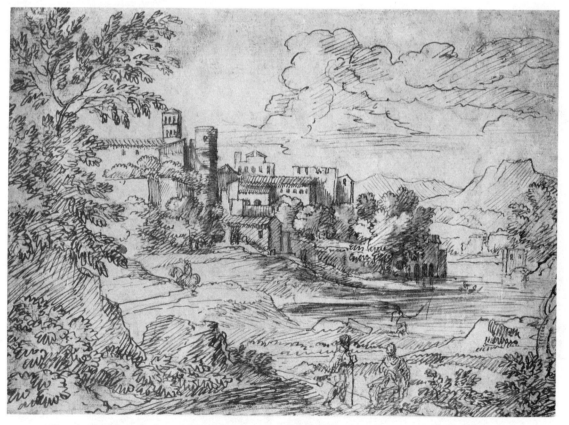

PLATE 3. "Landscape with a Town in the Middle Distance" by Gaspard Dughet.
Pen and bistre. A broad treatment of the buildings gives an harmonious total effect.

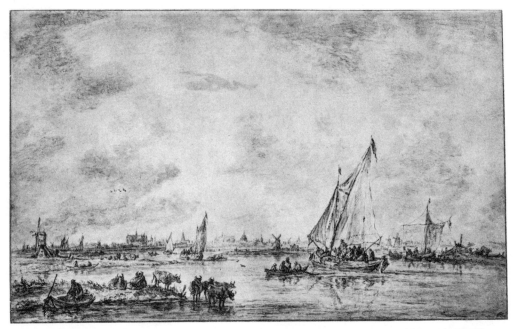

PLATE 4. "River Landscape with Cattle on the Banks: View of Nimeguen in the Distance" by Jan van Goyen. Black chalk washed with India ink. The use of brush, ink and water gives a lively effect to a broad sky.

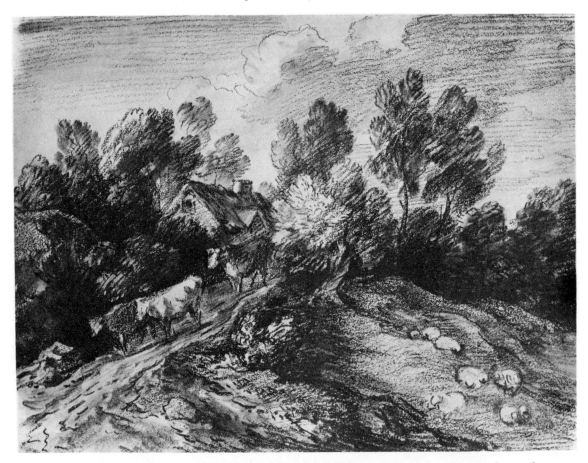

PLATE 5. "Hilly Landscape with Cows on the Road to Left, a Cottage beyond partly Hidden by Trees" by Thomas Gainsborough. Black and white chalk. The simple massing of elements with angles adds to the composition.

PLATE 6. "Landscape with Horse and Cart Descending the Hill" by Thomas Gainsborough. Black chalk. A dramatic example of movement is this well-planned, spacious composition.

PLATE 7. "Landscape Overlooking a Plain, with Low Hills in the Distance to Right" by Claude Lorraine. Pen and bistre, washed. Distinct use of sharply defined planes to achieve an illusion of distance.

PLATE 8. "Landscape with Figures" by S. Bourdon. Red chalk. This sketch demonstrates the principle of effective economy of detail in a complex composition.

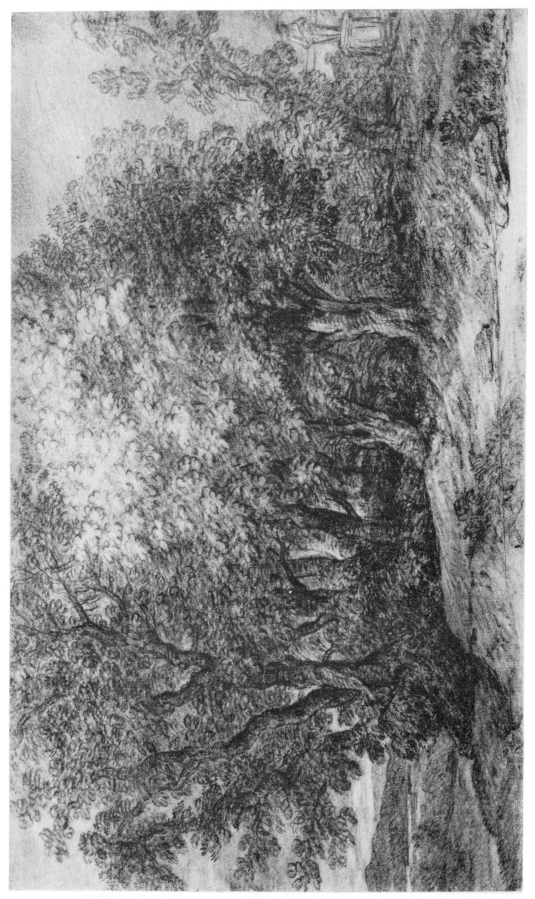

PLATE 9. "A Wooded Landscape" by Jean Baptiste Oudry. Red and black chalk heightened with white, on grey paper. Both line work and lighting give solidity and form to foliage and trunks.

PLATE 10. "Landscape with Cattle" by J. van Strij. Pen and burnt sienna, washed with India ink. A simple ink wash brings out the drawing in trees and sky.

PLATE 11. "A Mill Stream nearly Dry; a Thatched Shed to Left" by J. Ruysdael. Pen and India ink wash. Clear draftsmanship in the building provides the main element of interest.

PLATE 12. "Landscape with a Hunting Party" by Jan van der Vinne. Pen and bistre, washed. The figures in this open landscape focus the entire composition.

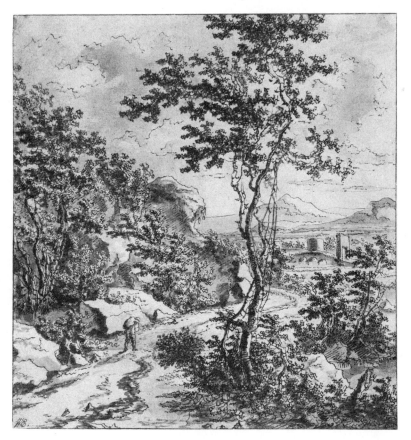

PLATE 13. "Italian Landscape" by J. Both. Pen and bistre, washed. Vivid sunlight through a well-composed use of sidelighting.

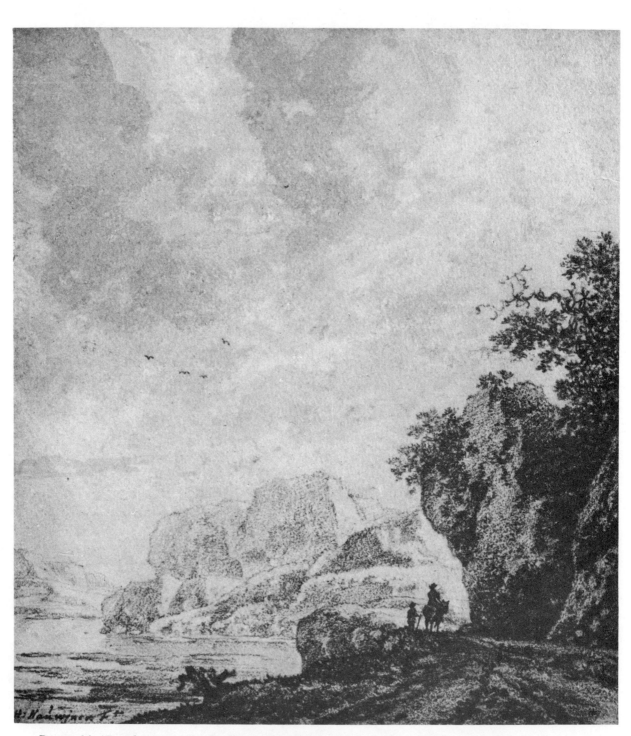

PLATE 14. "Landscape: a Rocky River Shore" by H. Nauwjncx. Black chalk washed with sepia. The effective wash treatment of the light sky strengthens the foreground forms.

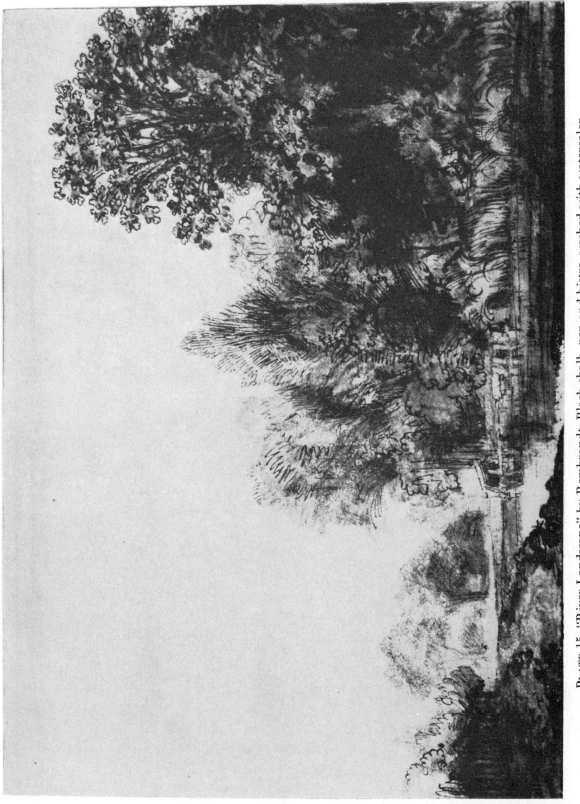

PLATE 15. "River Landscape" by Rembrandt. Black chalk, pen and bistre, washed with watercolor. The technique in trees and reflections gives a forceful perspective.

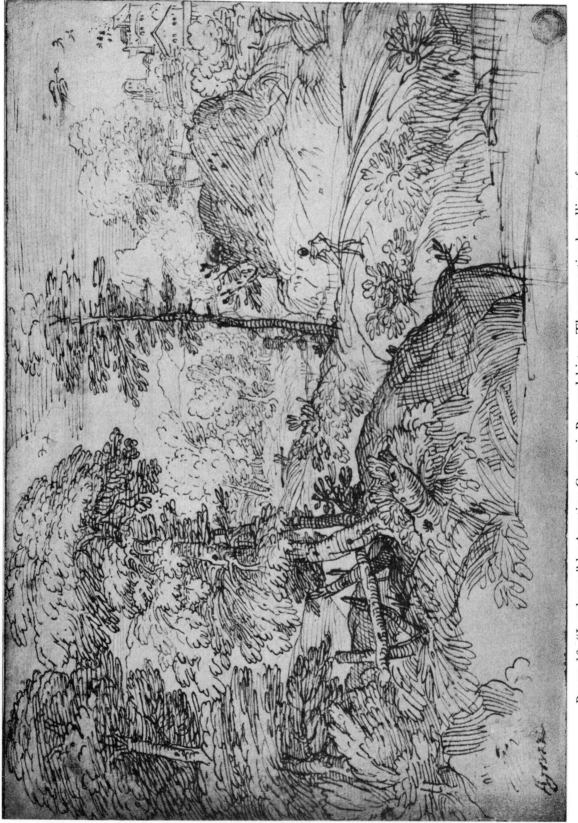

PLATE 16. "Landscape" by Agostino Carracci. Pen and bistre. The suggestive handling of masses and the lighting make for vigor with simplicity.

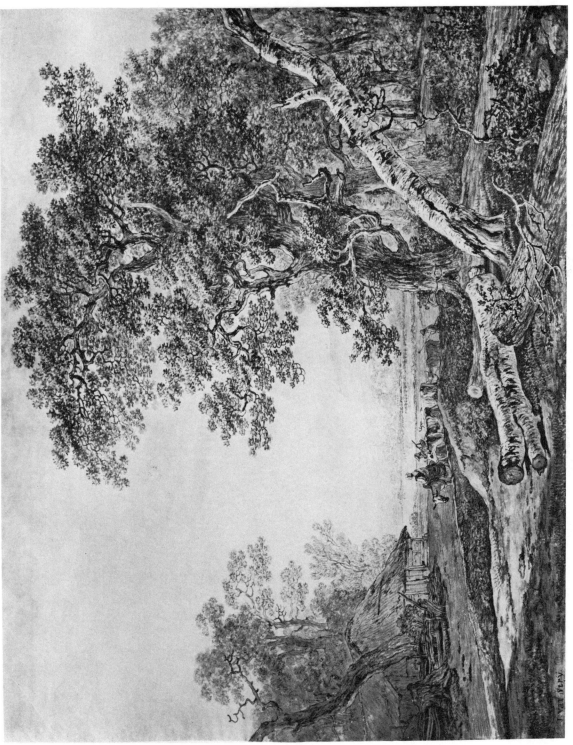

PLATE 17. "Landscape: a River in the Distance, a Felled Tree in the Foreground" by J. van Strij. Bistre, washed. Note the effective technique of detail in the foliage.

PLATE 18. "Landscape with Cottages on a Bank to Right above a Sandy Road" by Jan van Goyen. Black chalk washed with bistre. An impressive blend of figures and buildings in simplified forms.

PLATE 19. "Landscape: Evening" by Thomas Gainsborough. Black chalk. Instructive because of the strong handling of the main forms and masses in a broad subject.